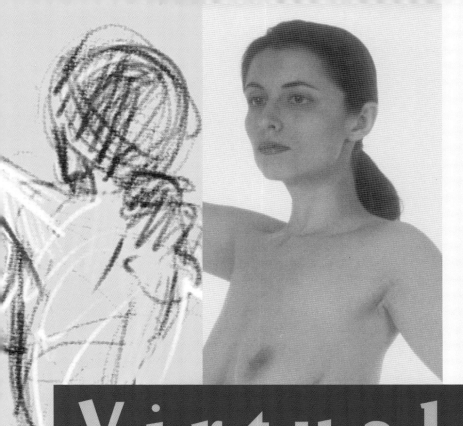

The Ultimate Visual Reference Series
for Drawing the Human Figure

Virtual Pose

MAC/PC CD-ROM
ENCLOSED

Mario Henri Chakkour

Photography by Welton Doby

CD-ROM produced by Gregory Scott Wills

DESIGN BOOKS INTERNATIONAL

VIRTUAL POSE™
The Ultimate Visual Reference Series for Drawing the Human Figure

by Mario Henri Chakkour

Published by
Design Books International
5562 Golf Pointe Drive, Sarasota, FL 34243 USA
TEL 941-355-7150 FAX 941-351-7406

Distributed by
North Light Books, an imprint of F&W Publications, Inc.
1507 Dana Avenue, Cincinnati, Ohio 45207
TEL 513-531-2222, 800-289-0963

Creative Direction: Mario Henri Chakkour
Art Direction: Stephen Bridges
Design: Beth Santos
Photography: Welton Doby
Female Model: Ruzena Jelinkova
Male Model: Jason Benson
CD-ROM Produced by Gregory Scott Wills

Music by EmZ™

Visit us on the web @ http://www.virtualpose.net

ISBN 0-9666383-1-X

03 02 01 00 5 4 3

Printed in Hong Kong

Contents

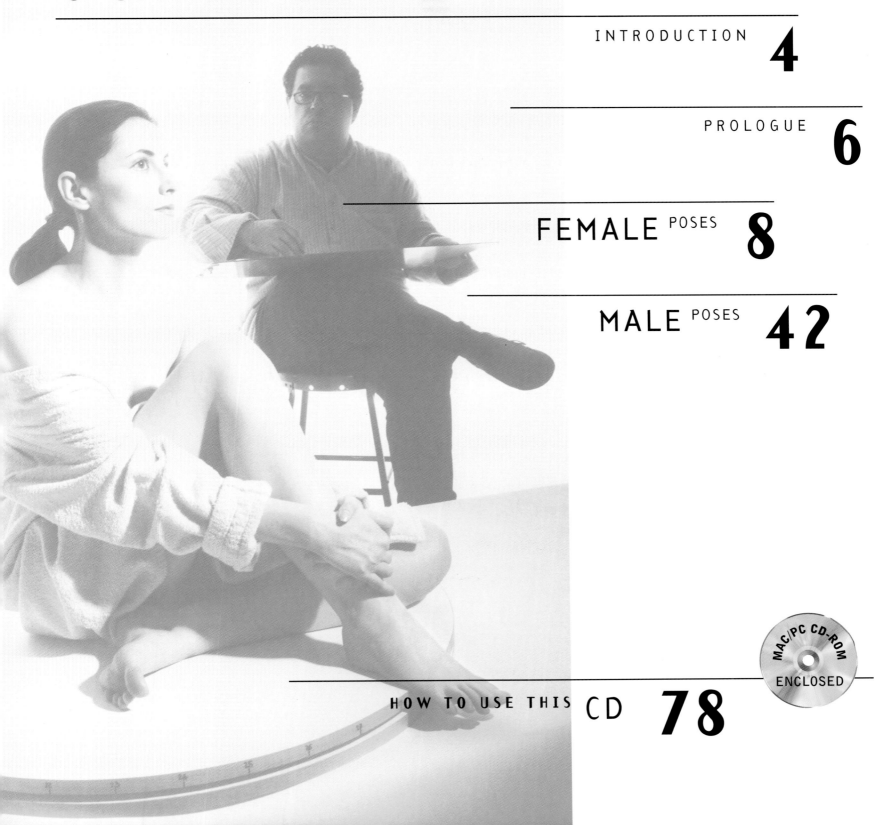

MAC/PC CD-ROM ENCLOSED

Drawing the human form is a rite of passage every artist must undertake. From the neophyte to the master, the visual interpretations of the body is never a fait accompli. Rather, it is a laborious process that may require many revisions and studies before reaching closure. In addition to being a three-dimensional landscape with curves, ridges and valleys, the human form speaks a silent language through a complex yet subtle arrangement of the limbs. The arrangement creates symbols that are so unified with the form, that breaking down the whole will never lead to the understanding of how the whole works. Yet, by doing just that, artists slowly mature into masters. This is the magic that all artists hope to experience.

Virtual Pose is designed to promote drawing. By allowing the artist to rotate the model at will, the mind can build a better picture of the subject in a way that is natural and easy to comprehend. The accompanying CD Rom consists of three components: the male and female poses, music and the tutorial movies. The tutorials show and discuss four life-drawing sketches being created from scratch. There, the emphasis is on drawing rhythmically and holistically. The music was composed and recorded especially for this project. It features amazing solos by maestro and flute virtuoso Matus Betko whose lyrical passages will surely inspire you to draw.

On a very personal note, I do hope you like the musical piece named "Folk Rhapsody." It was produced around an unedited eight-minute-long improvised solo guitar track I recorded in 1985 in memory of Dahesh. The fact that this piece of music lives on in Virtual Pose, after lying dormant for so many years, is very special to me. For it was in Dahesh's private museum where, as a young child growing up in Beirut during the early sixties, I was initiated into the world of art.

Mario Henri Chakkour

The instinct to draw is a primitive and innate one. Images drawn on prehistoric cave walls give us some idea of how early women and men viewed themselves and how they lived their lives. Their markings reach out to us over the centuries, linking their hopes and fears to our own. And what human beings love to draw most is their bodies. From the stick figures of children to the sophisticated renderings of artists, human beings seem to have a need to say, "this is who we are, and this is how we see ourselves." I have always seen the human body as a beautiful monument. Working with it offers both a constant challenge and an endless fascination.

Corinne Whitaker

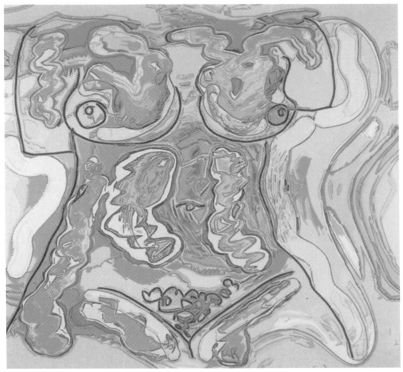

Corinne Whitaker "Body of a Woman"

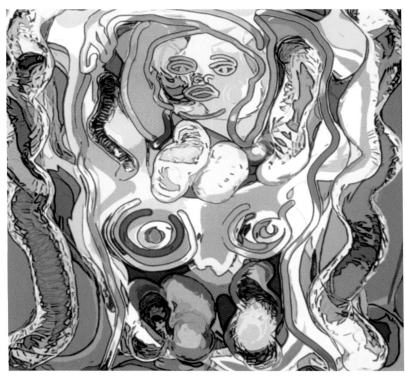

Corinne Whitaker "Breasts Like Papaya"

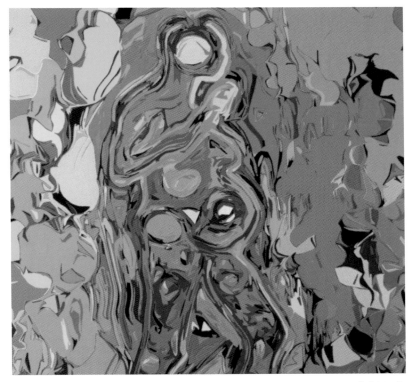

Corinne Whitaker "Waiting"

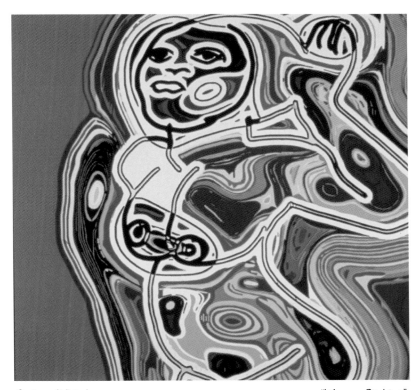

Corinne Whitaker "Woman Pitching"

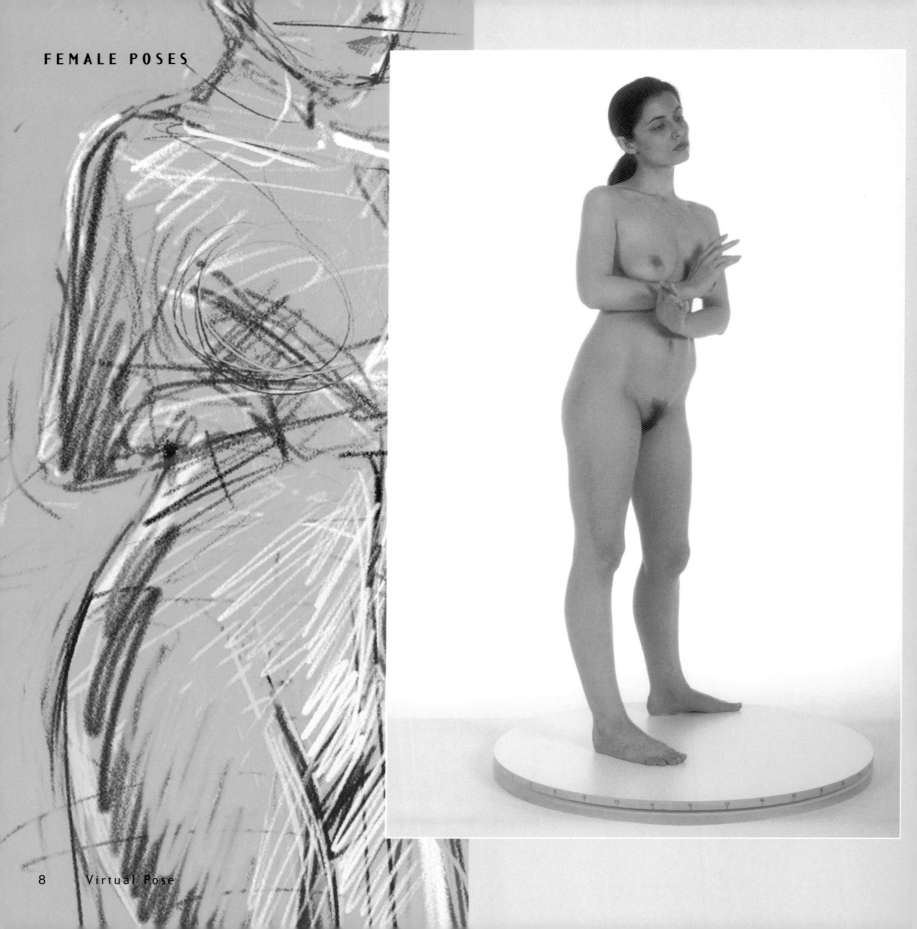

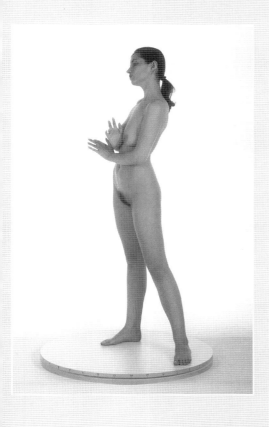
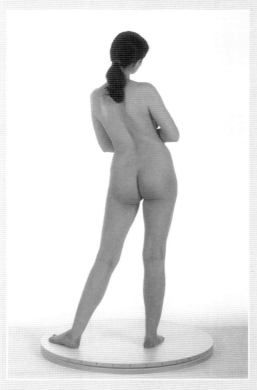
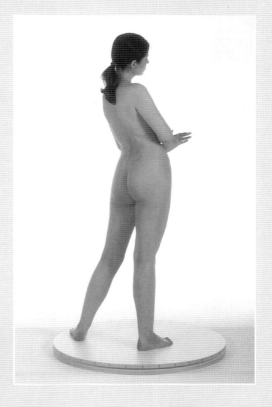
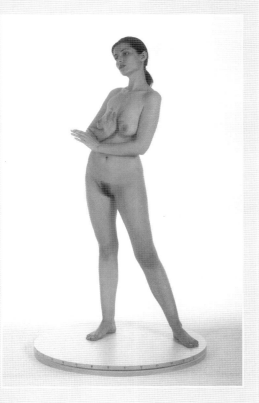
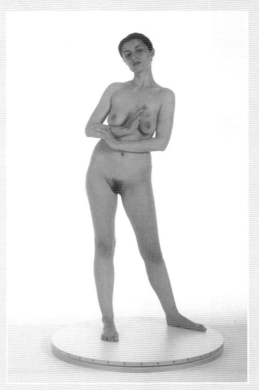
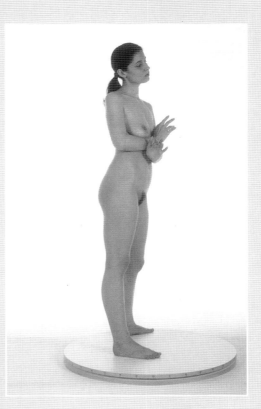

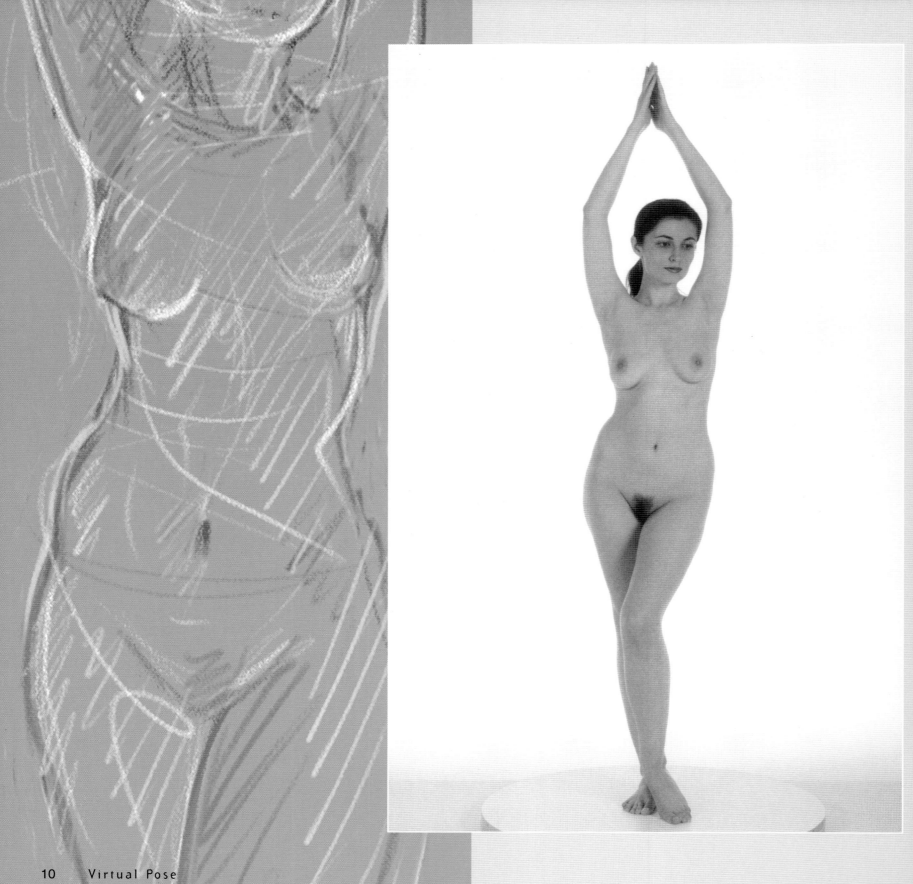

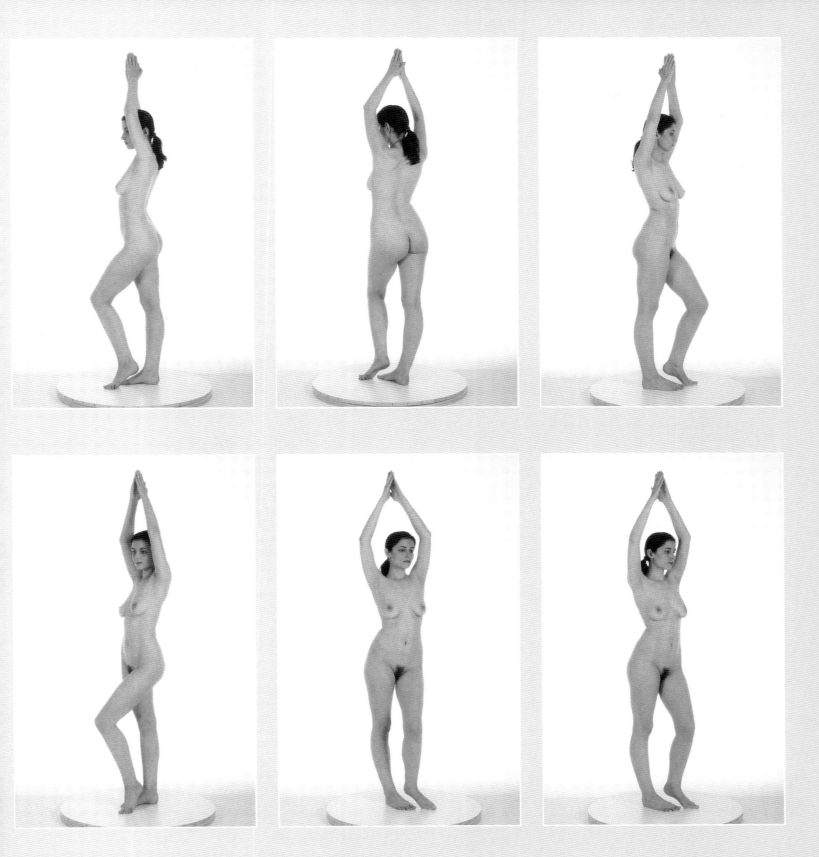

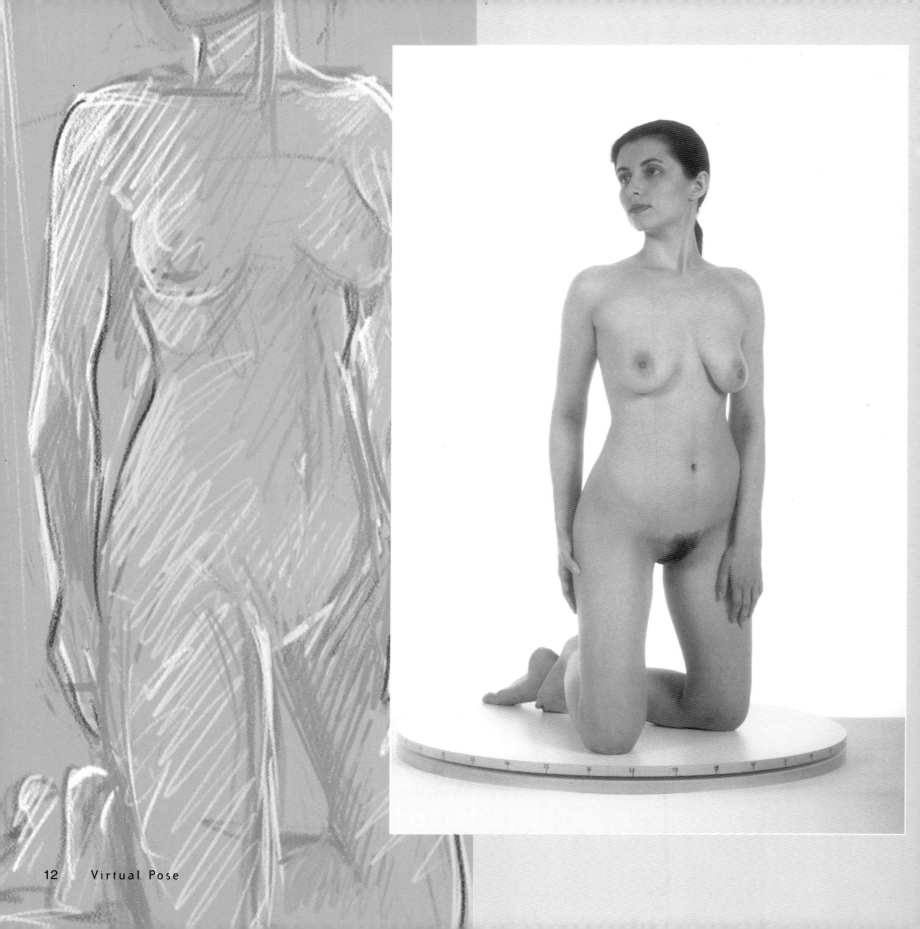

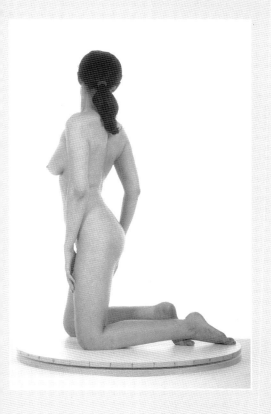
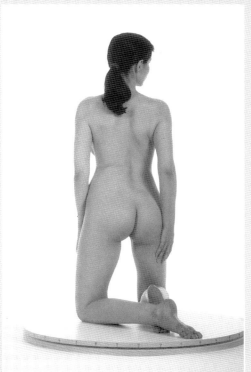
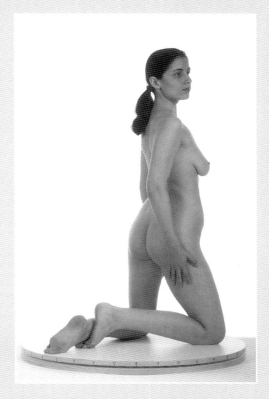
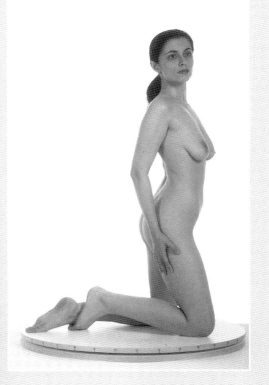
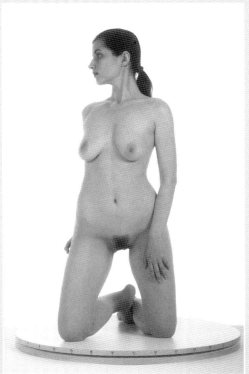
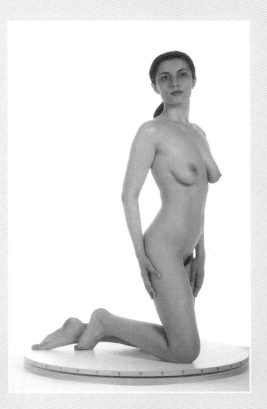

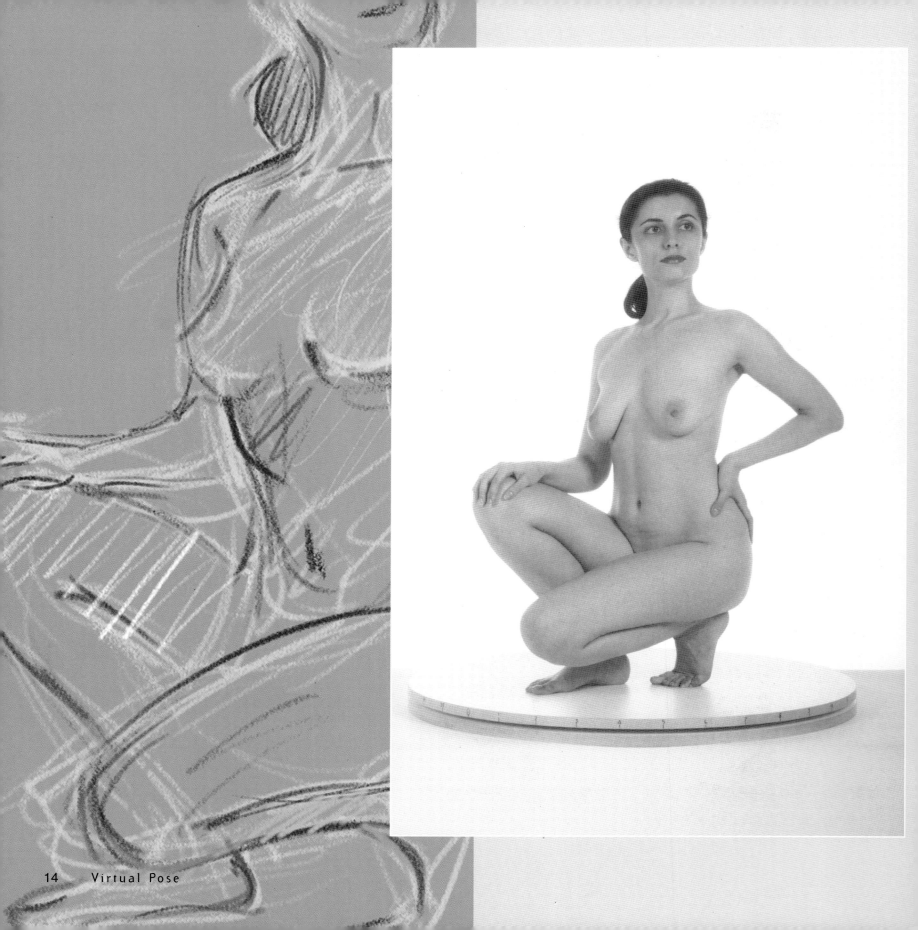

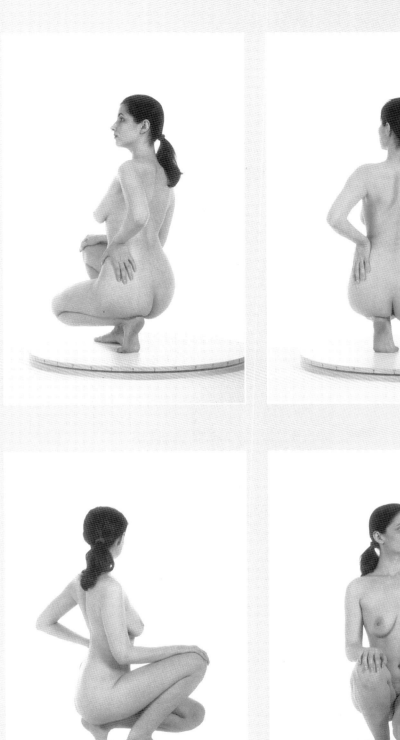
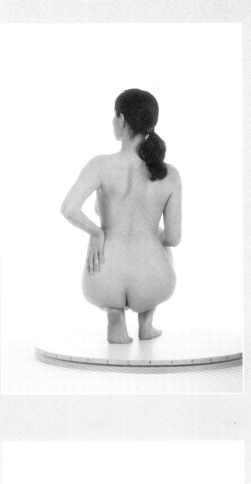
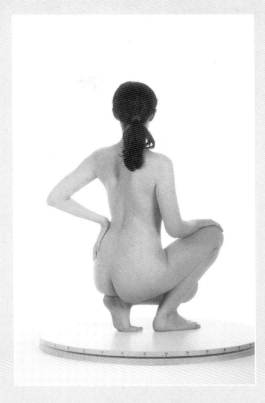
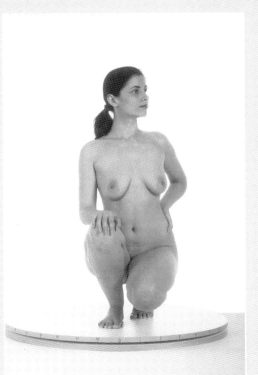
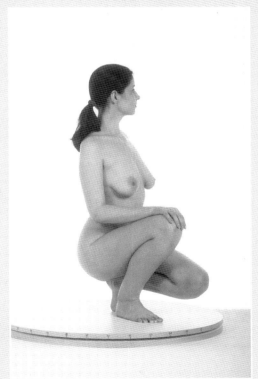

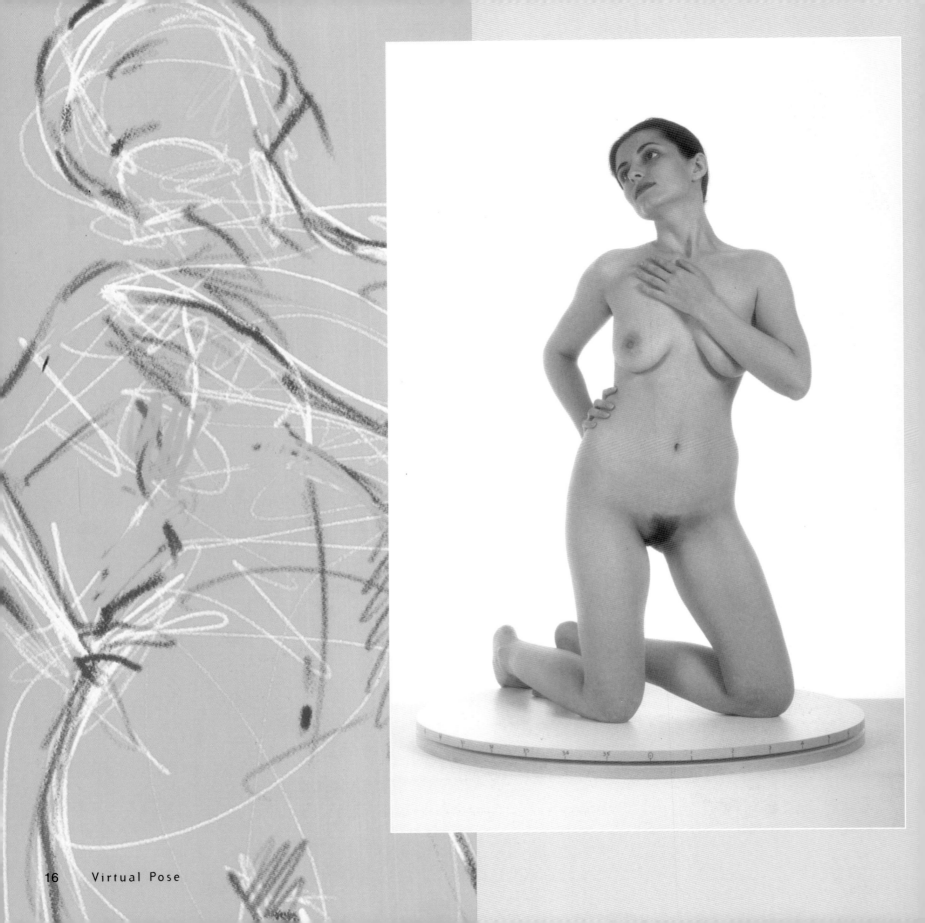

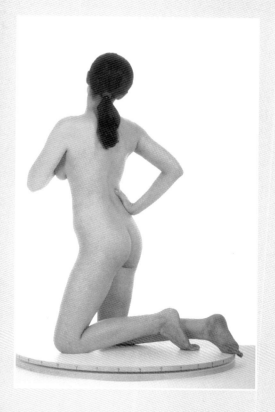
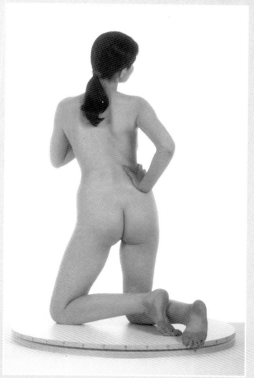
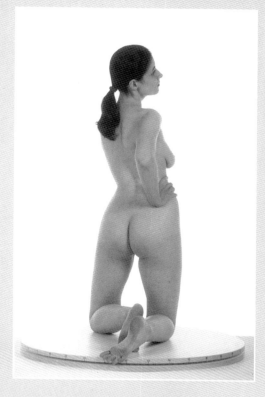
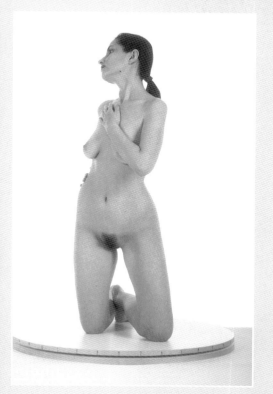
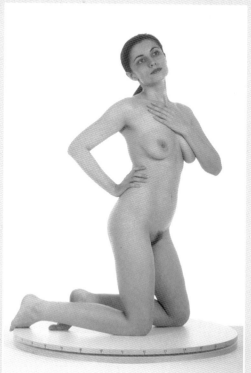
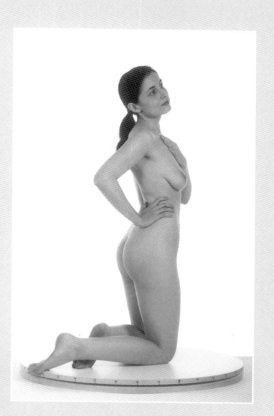

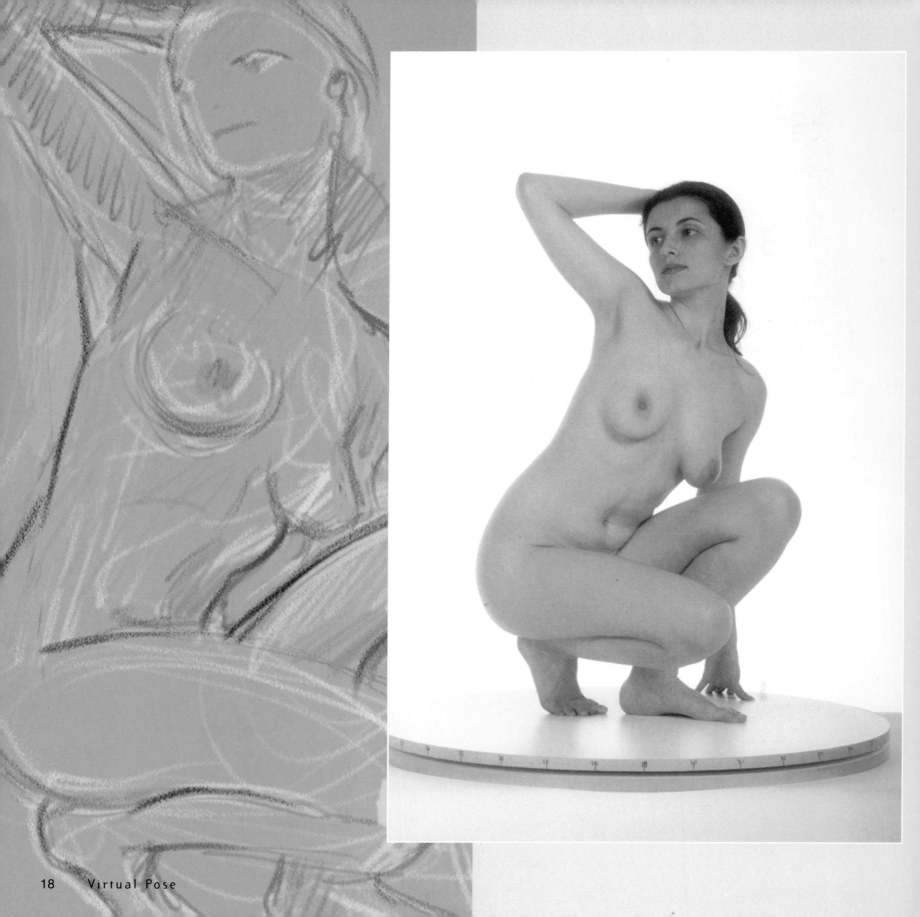

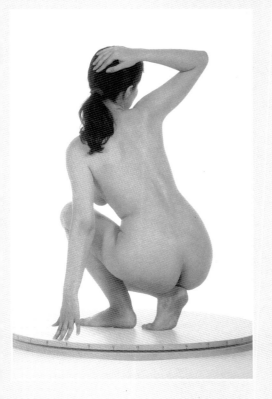
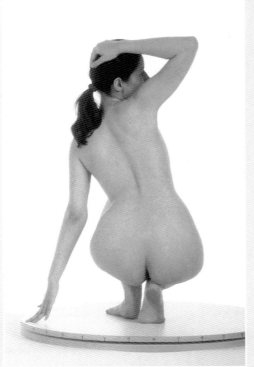
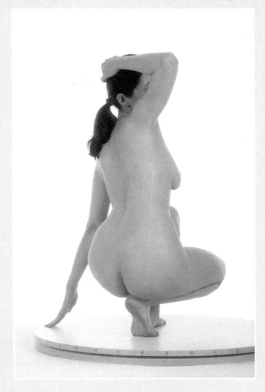
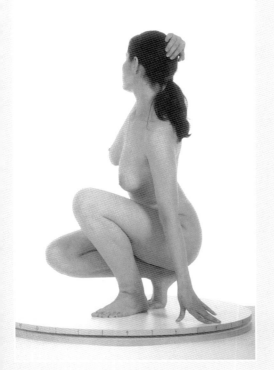
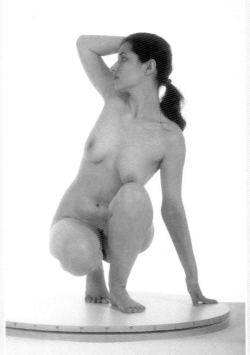
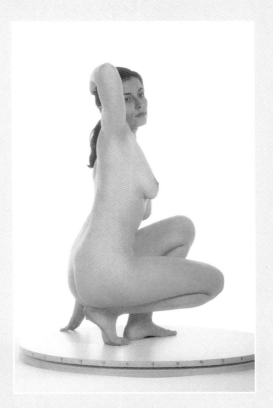

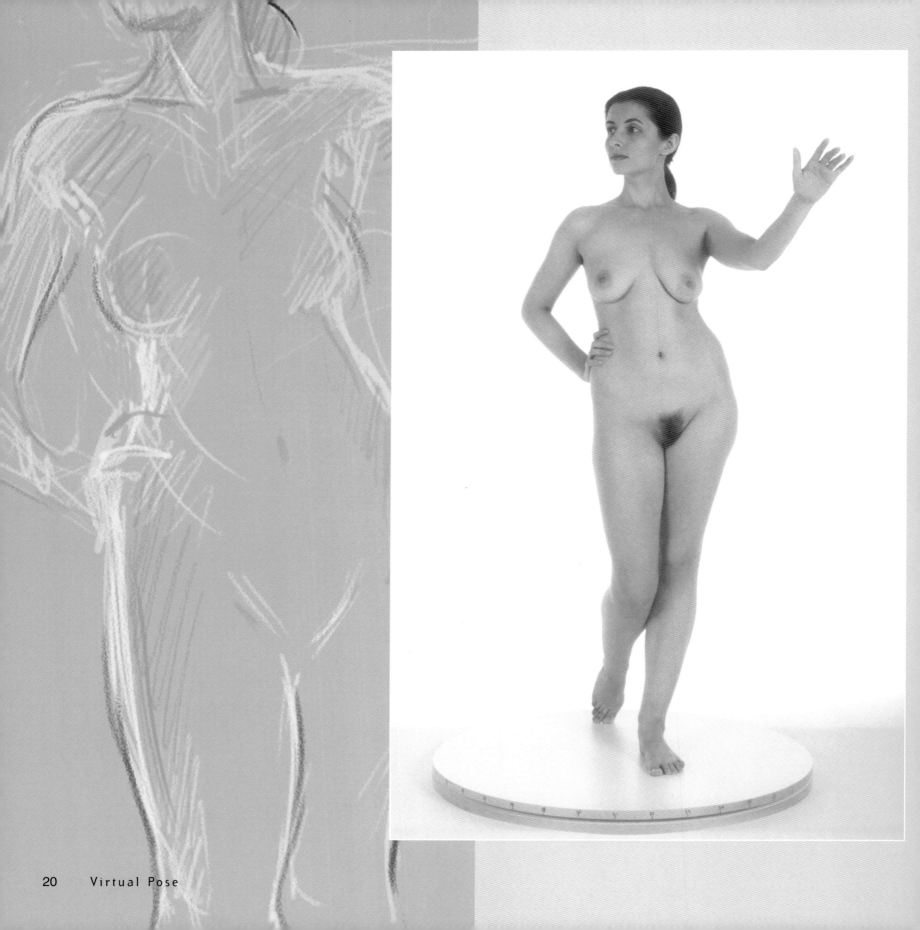

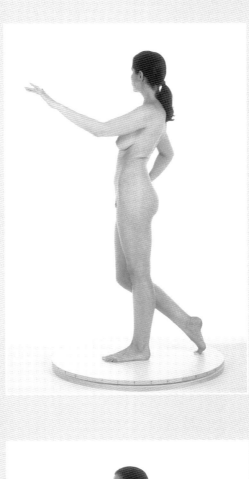
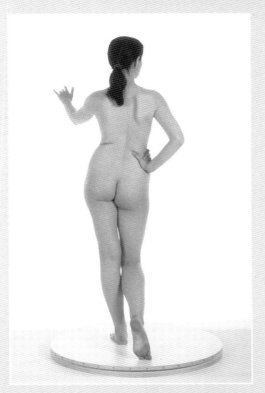
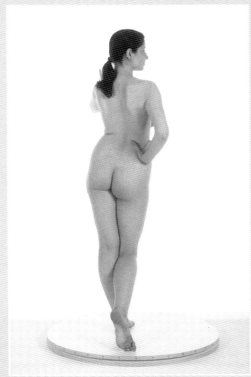
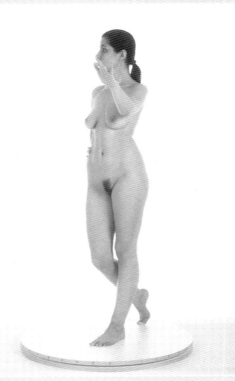
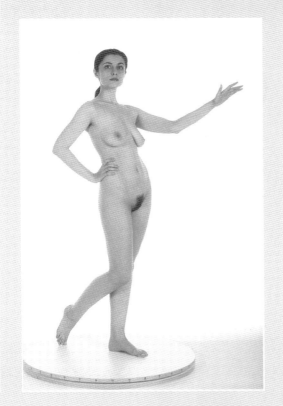
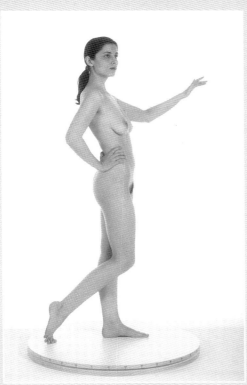

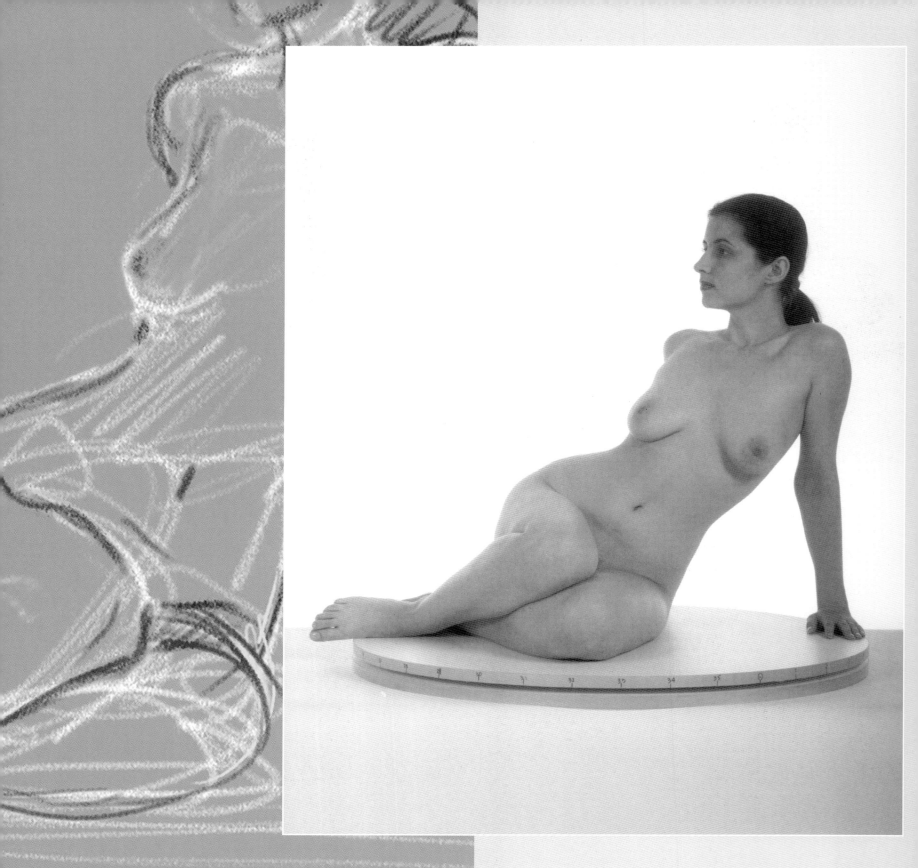

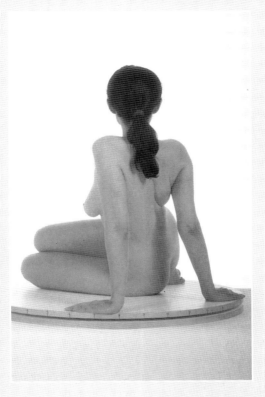
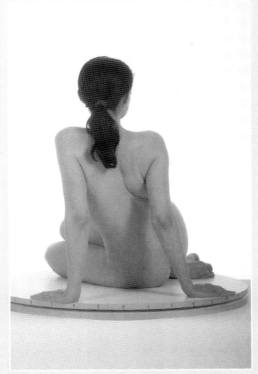
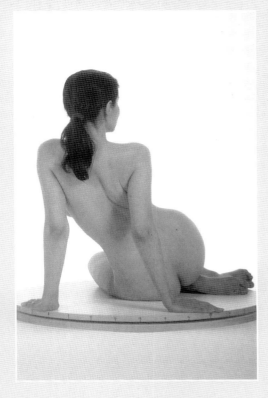
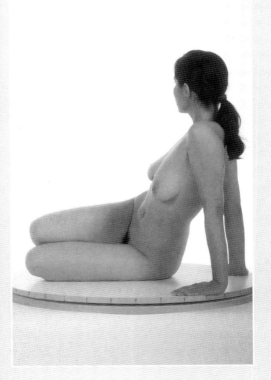
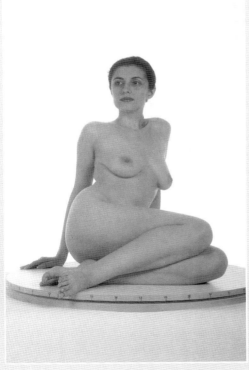
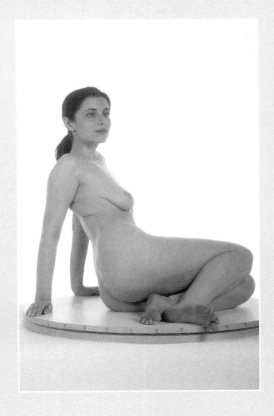

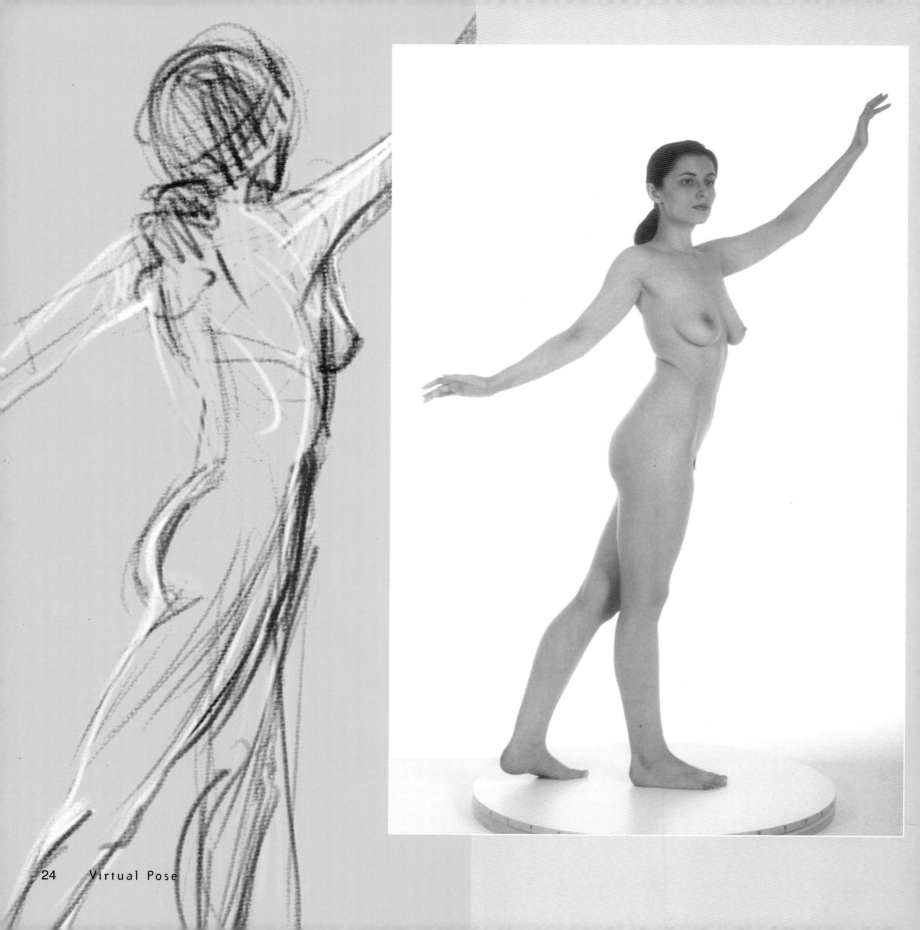

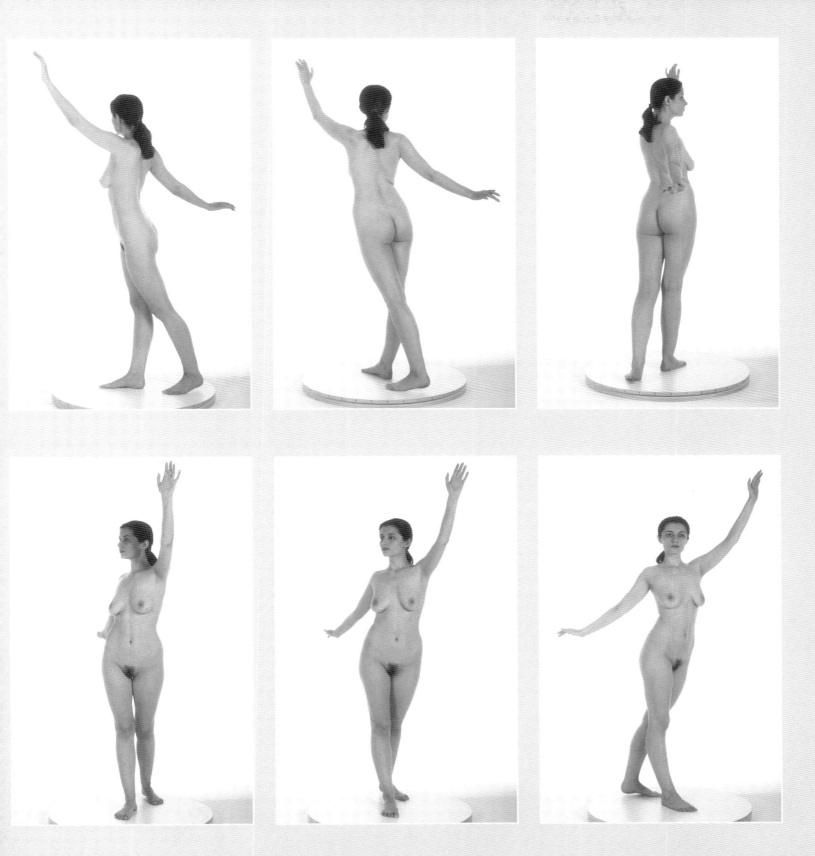

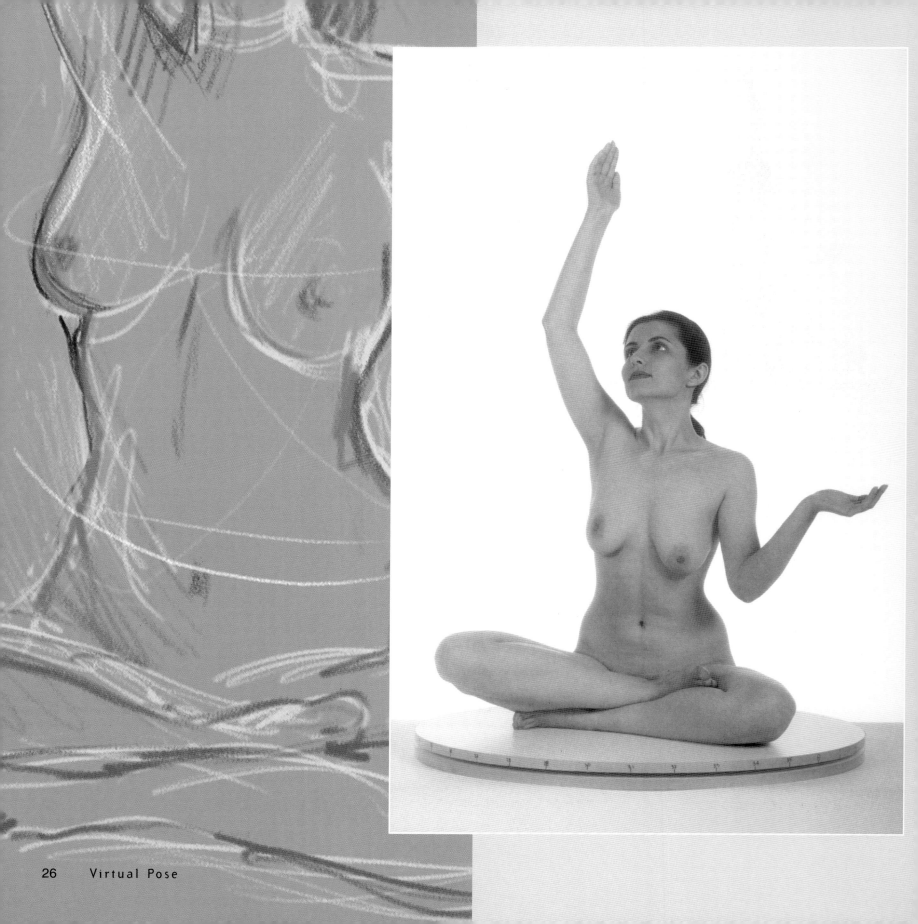

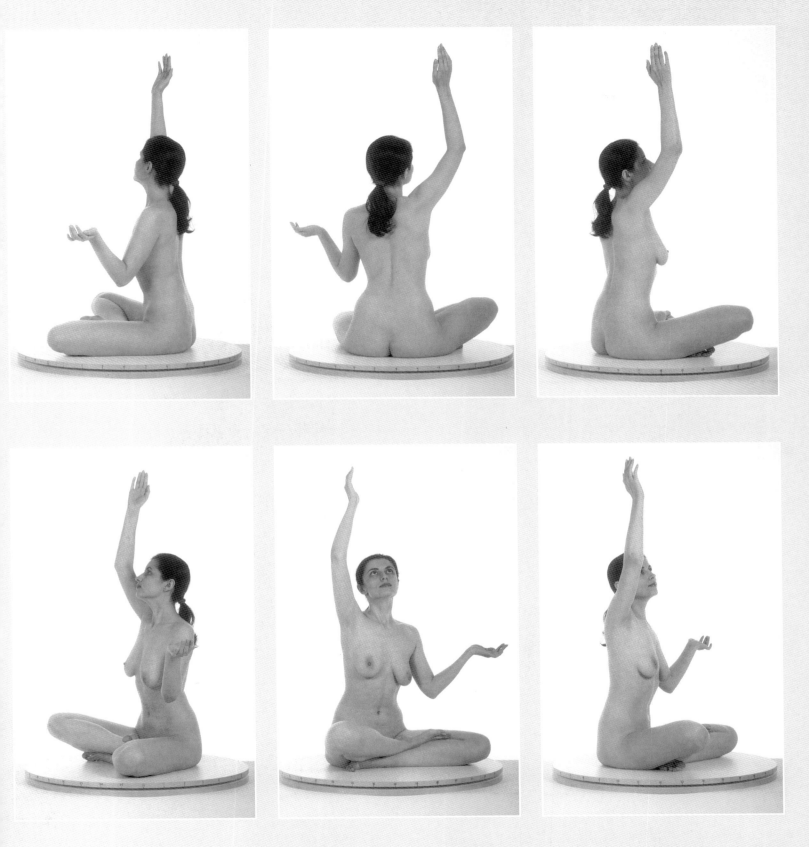

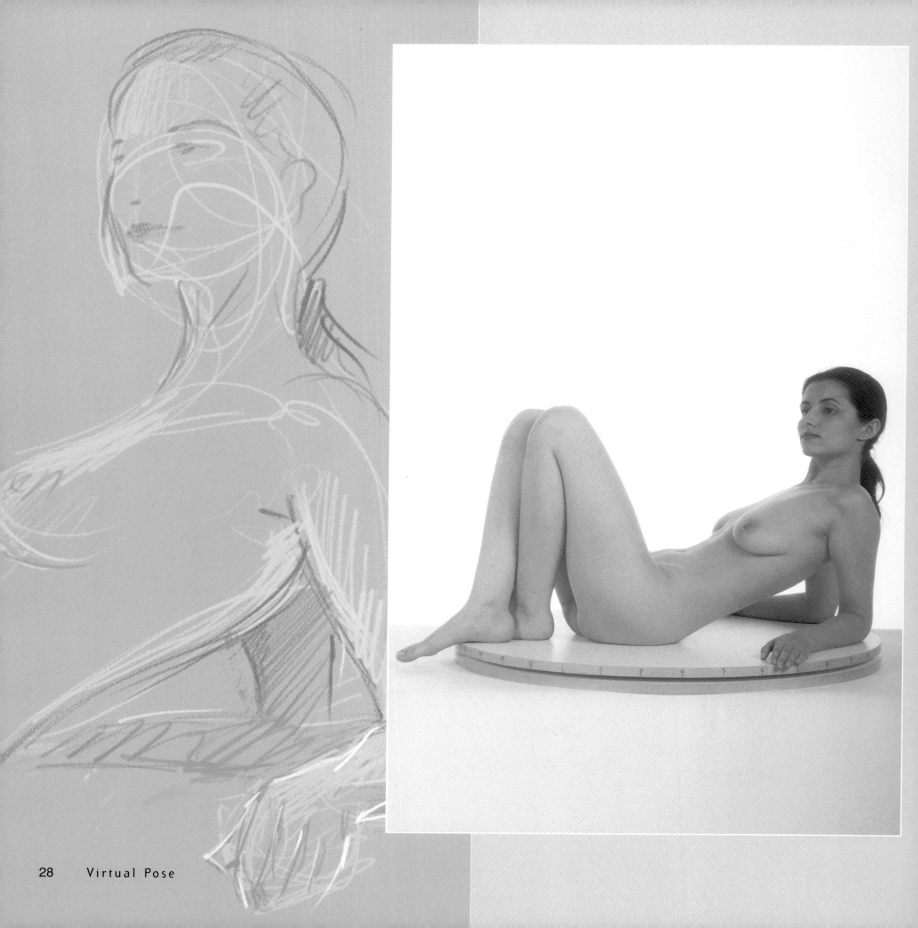

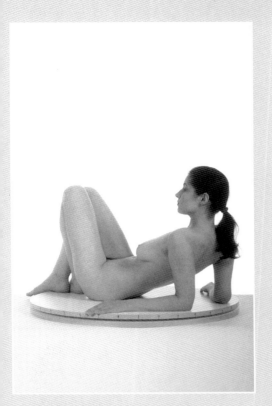
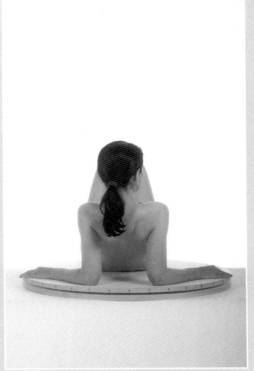
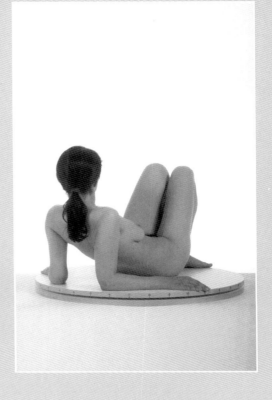
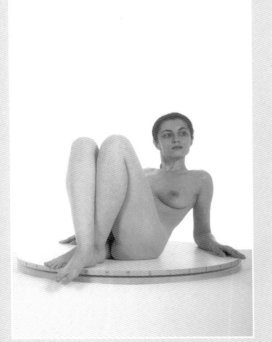
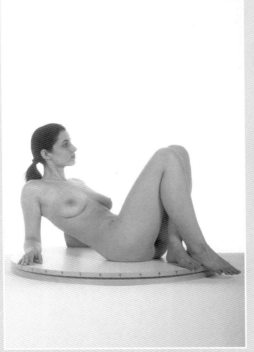
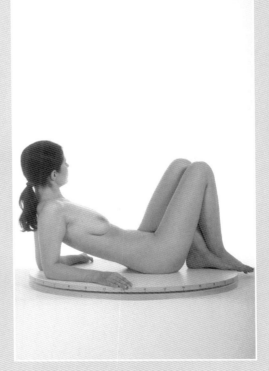

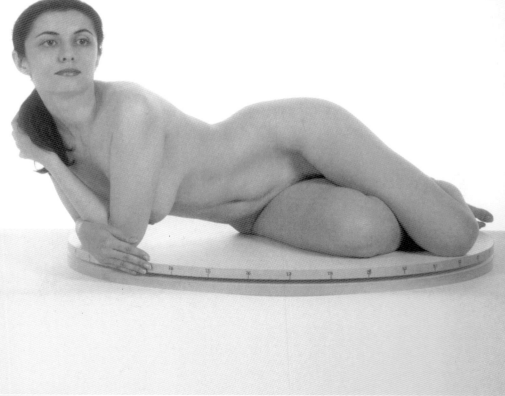

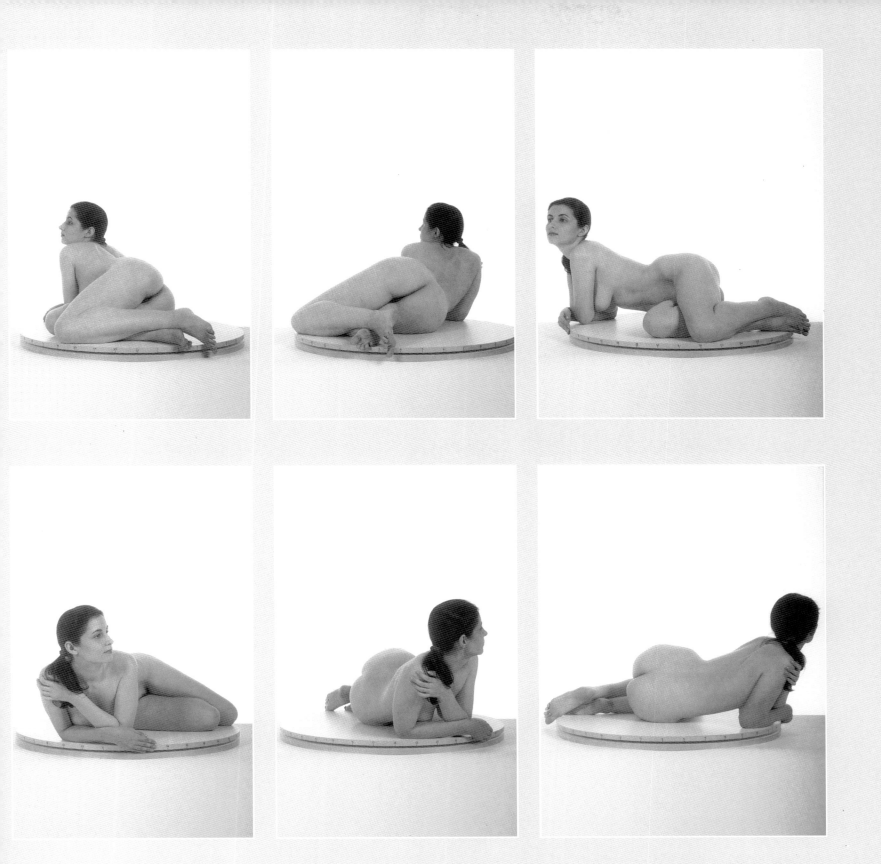

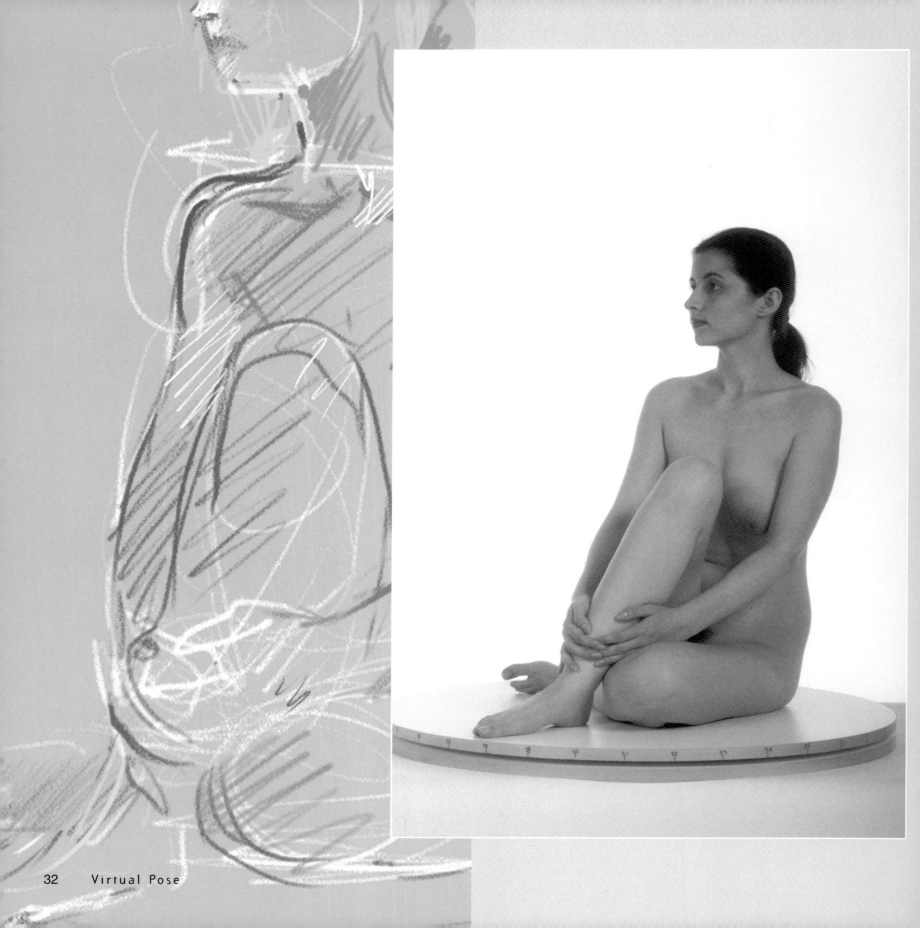

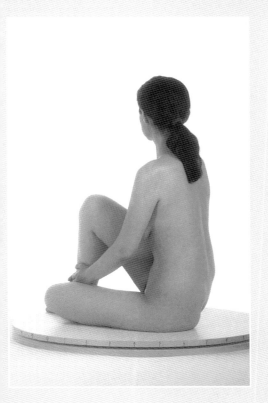
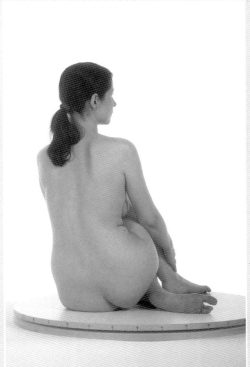
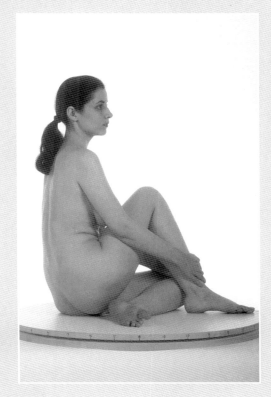
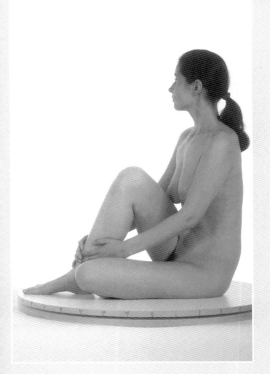
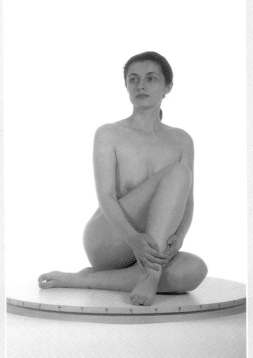
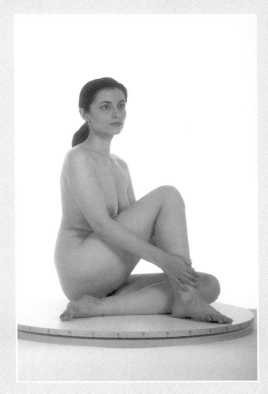

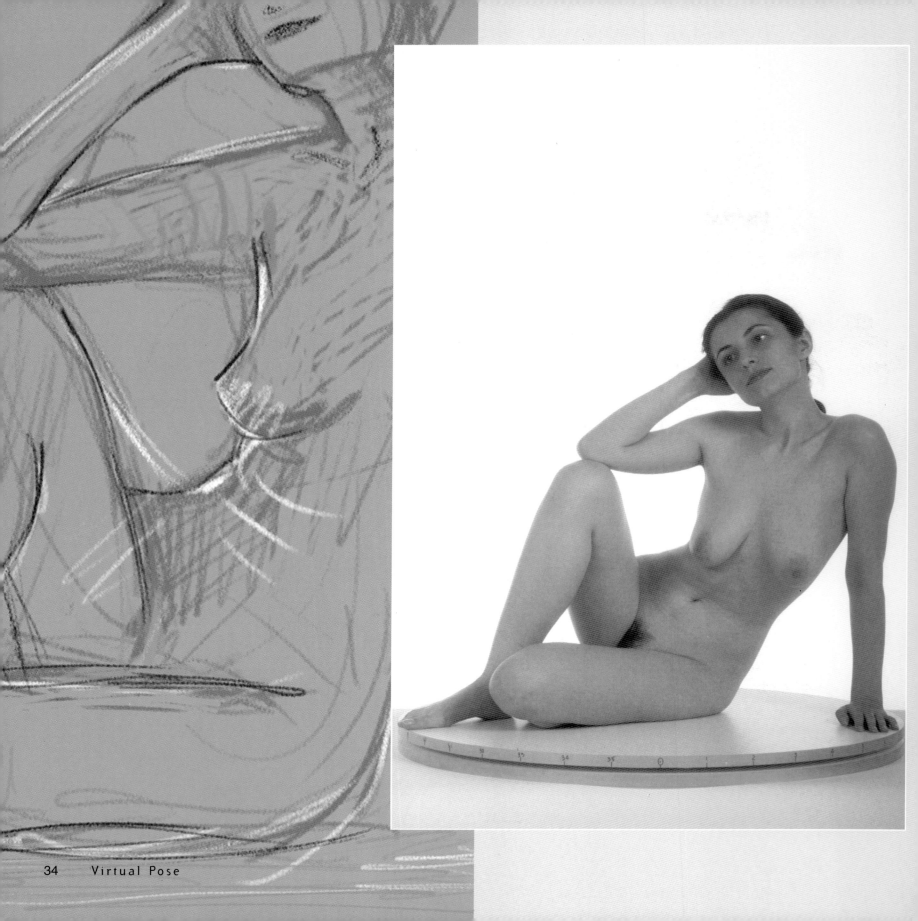

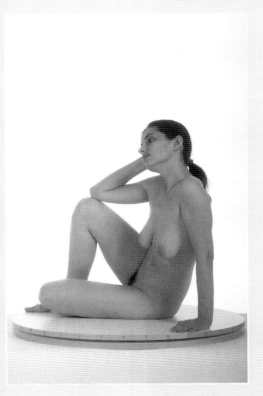
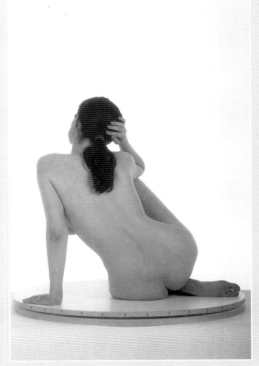
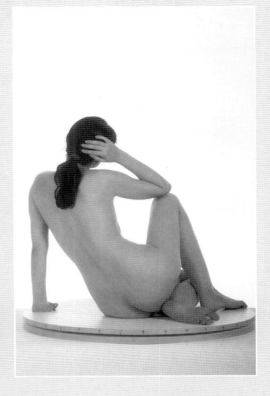
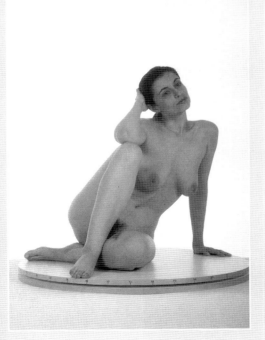
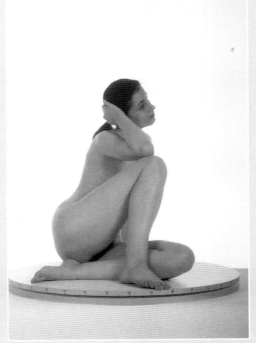
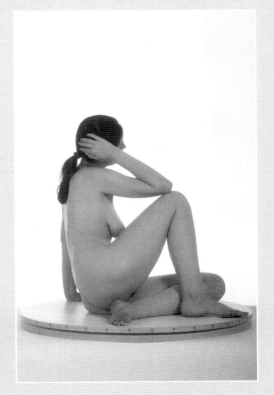

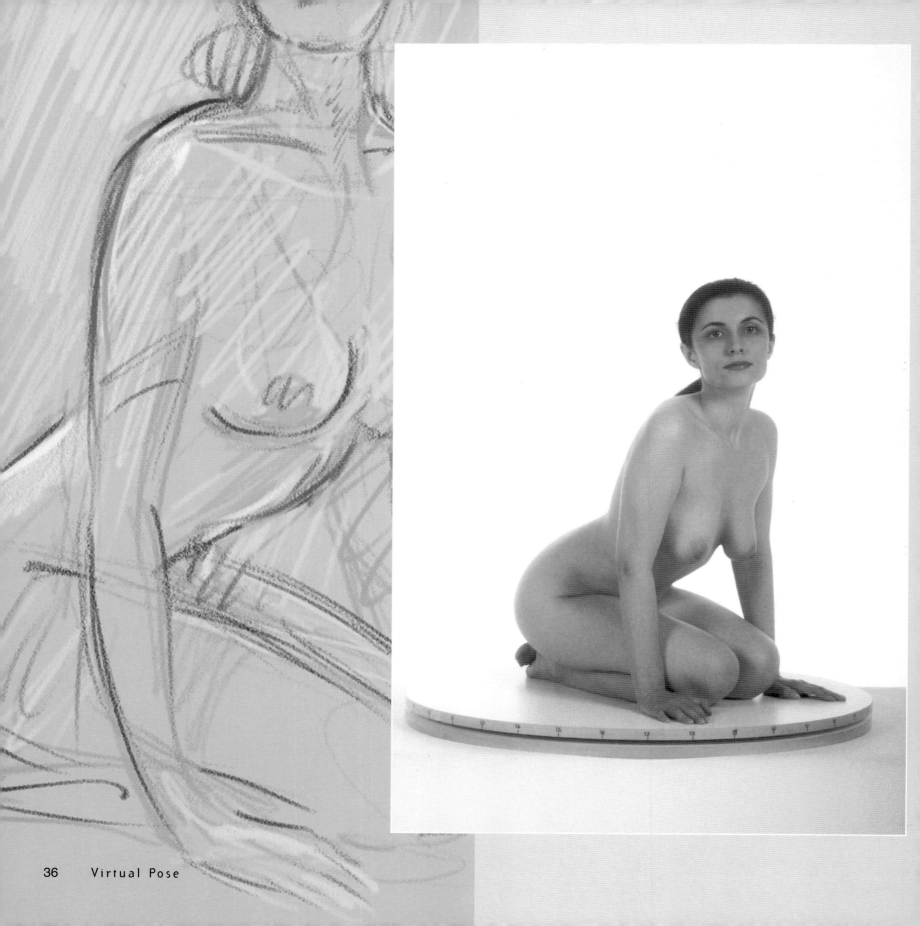

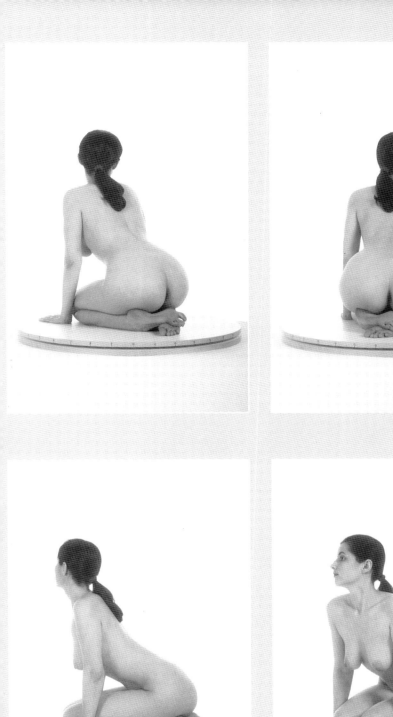
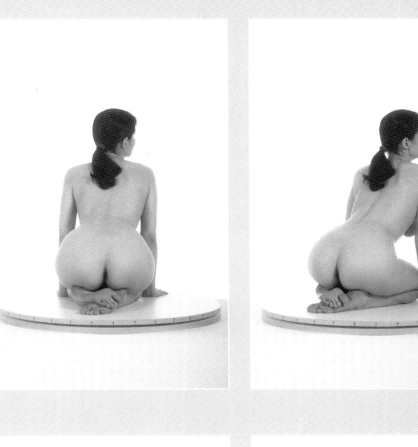
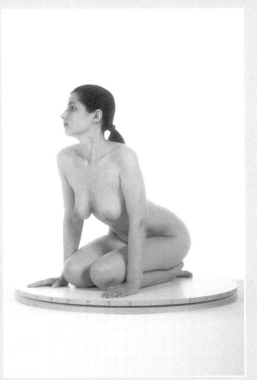
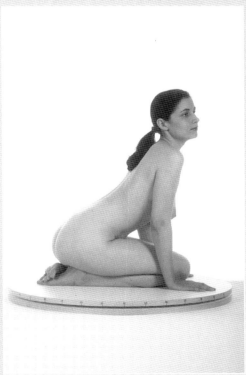

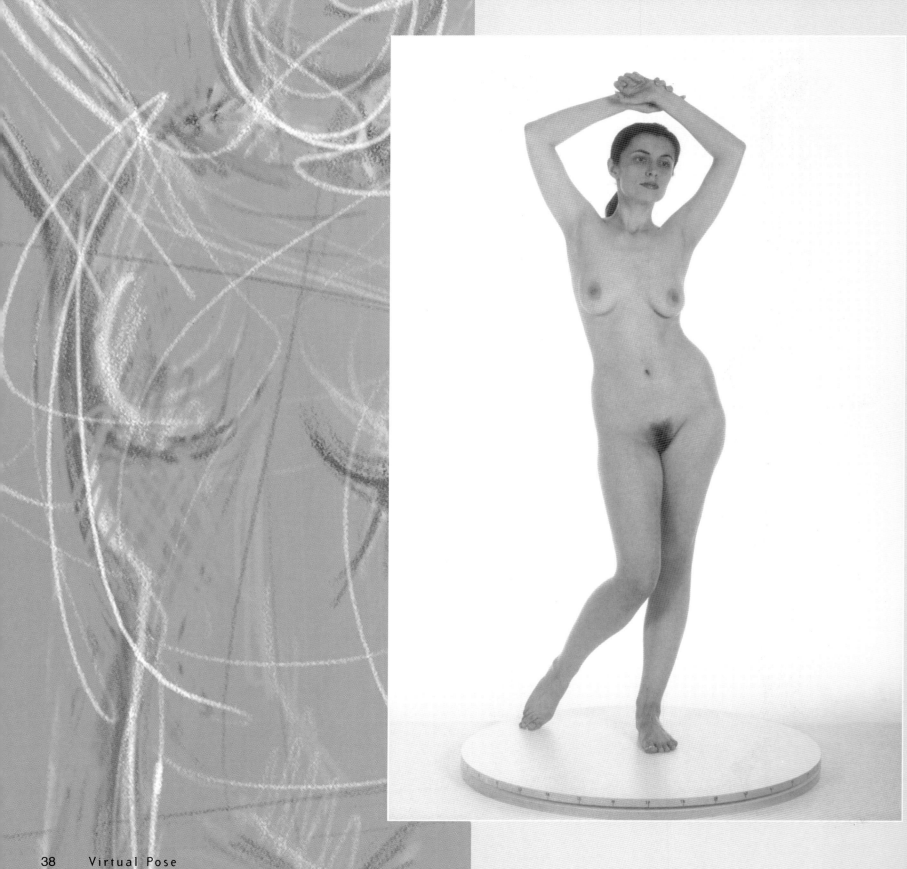

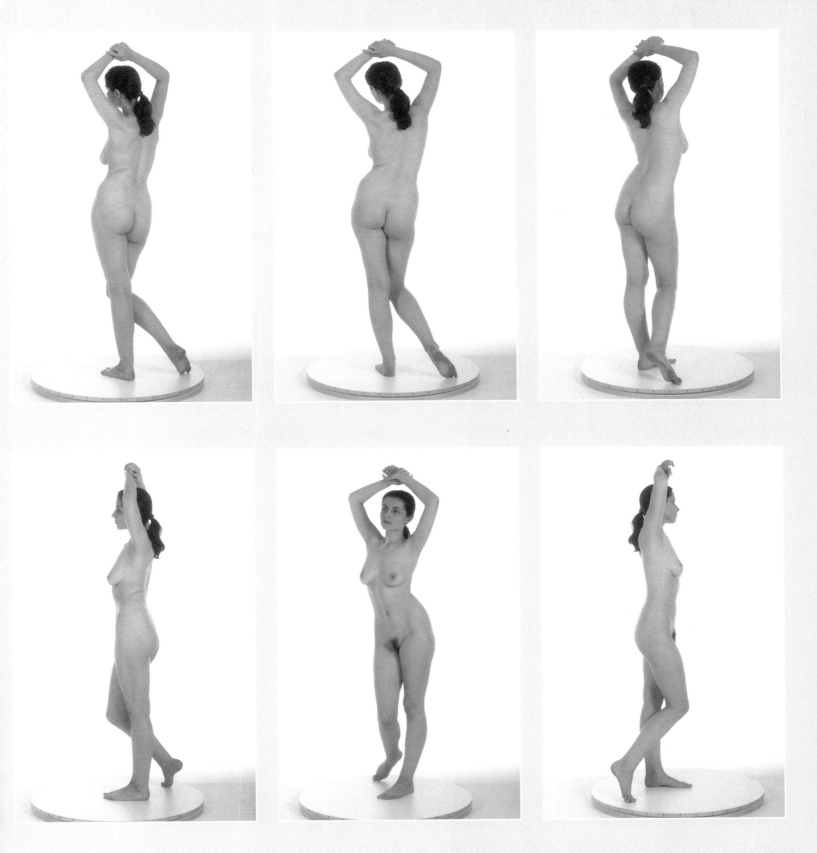

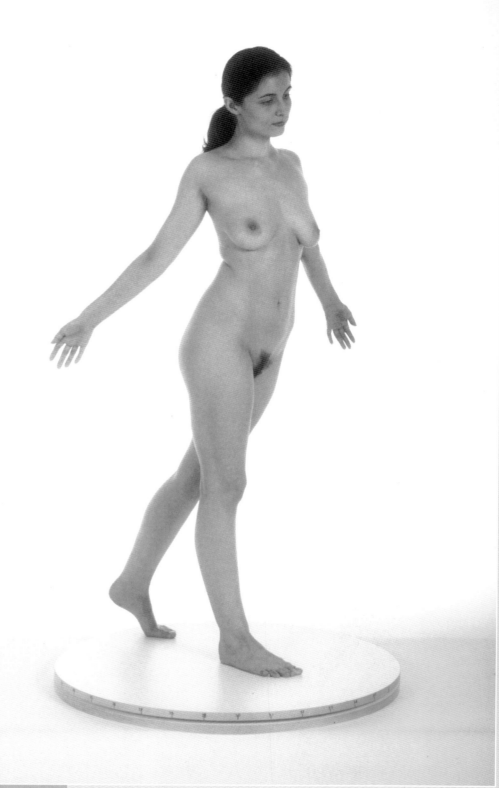

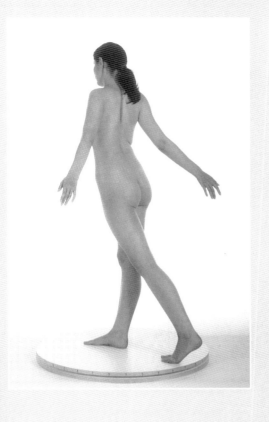
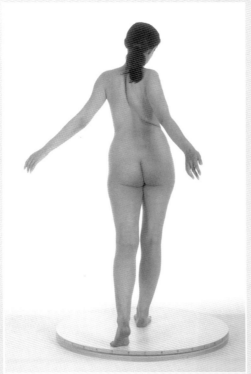
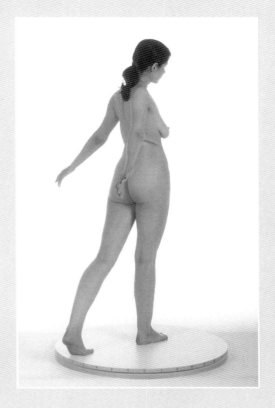
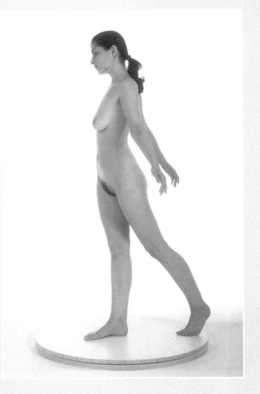
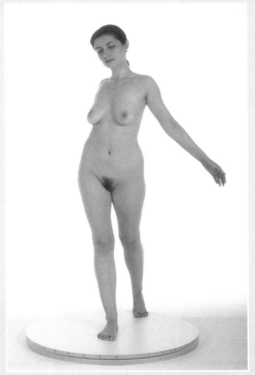
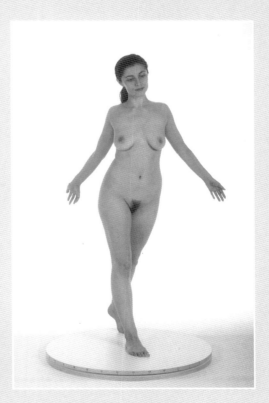

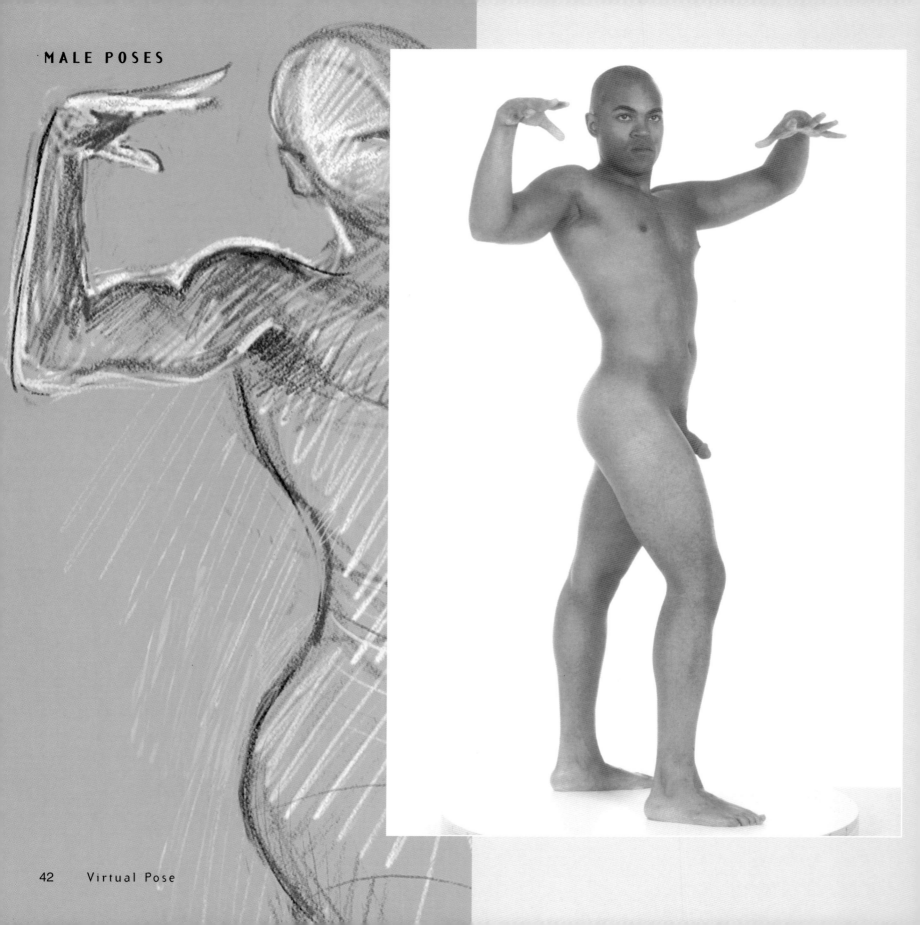

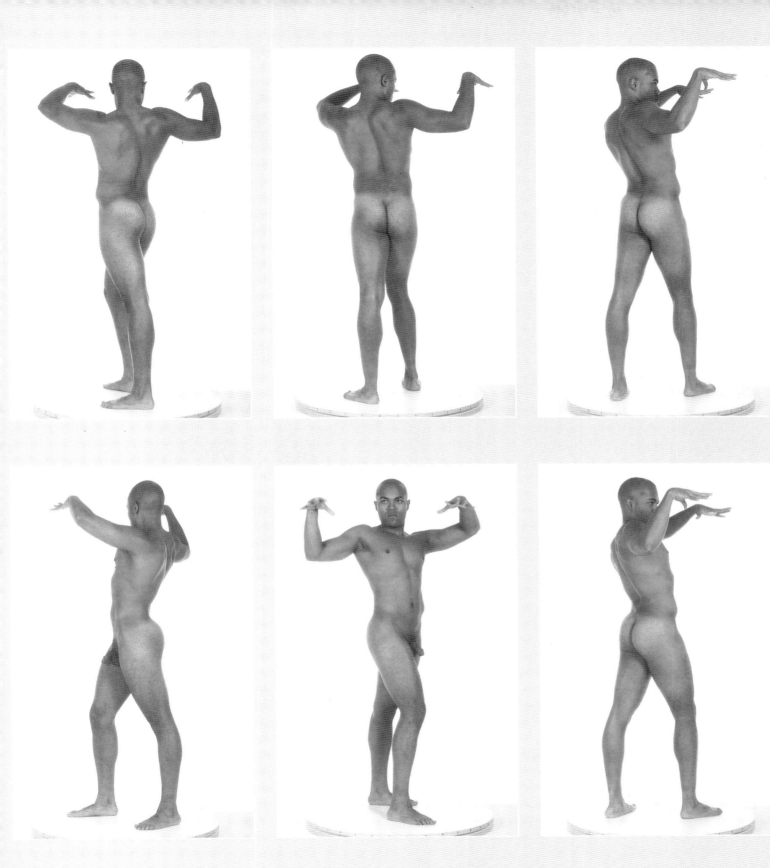

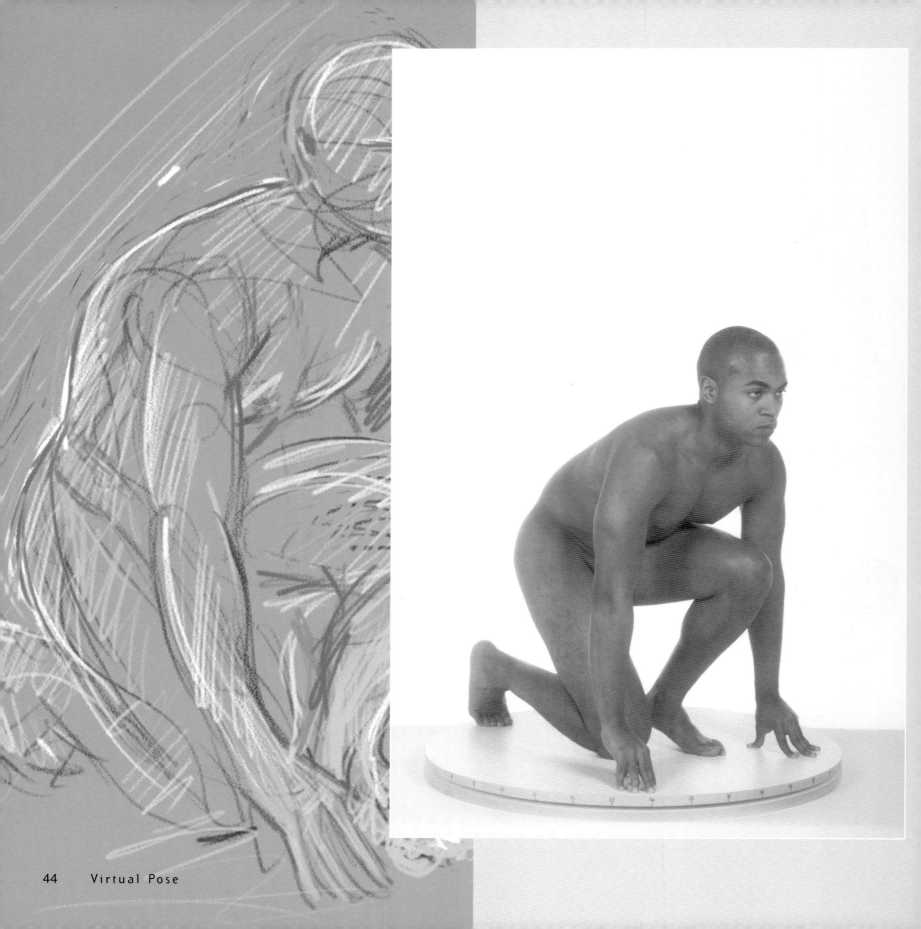

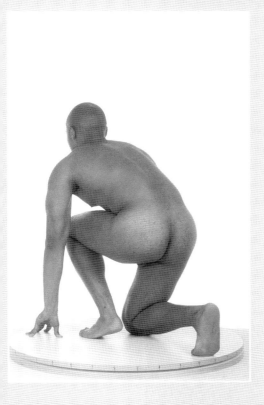
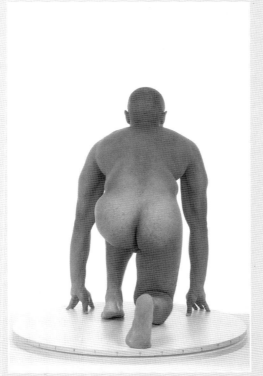
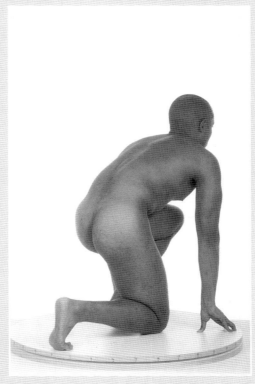
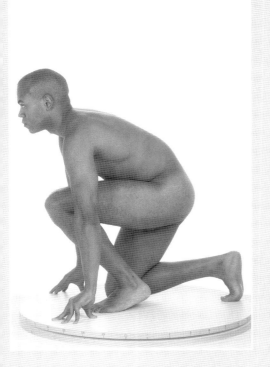
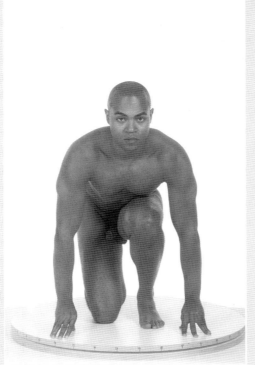
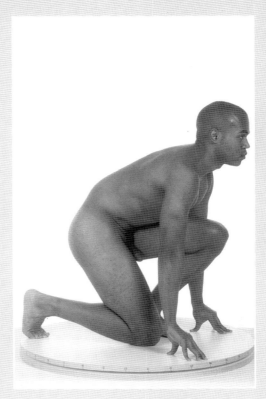

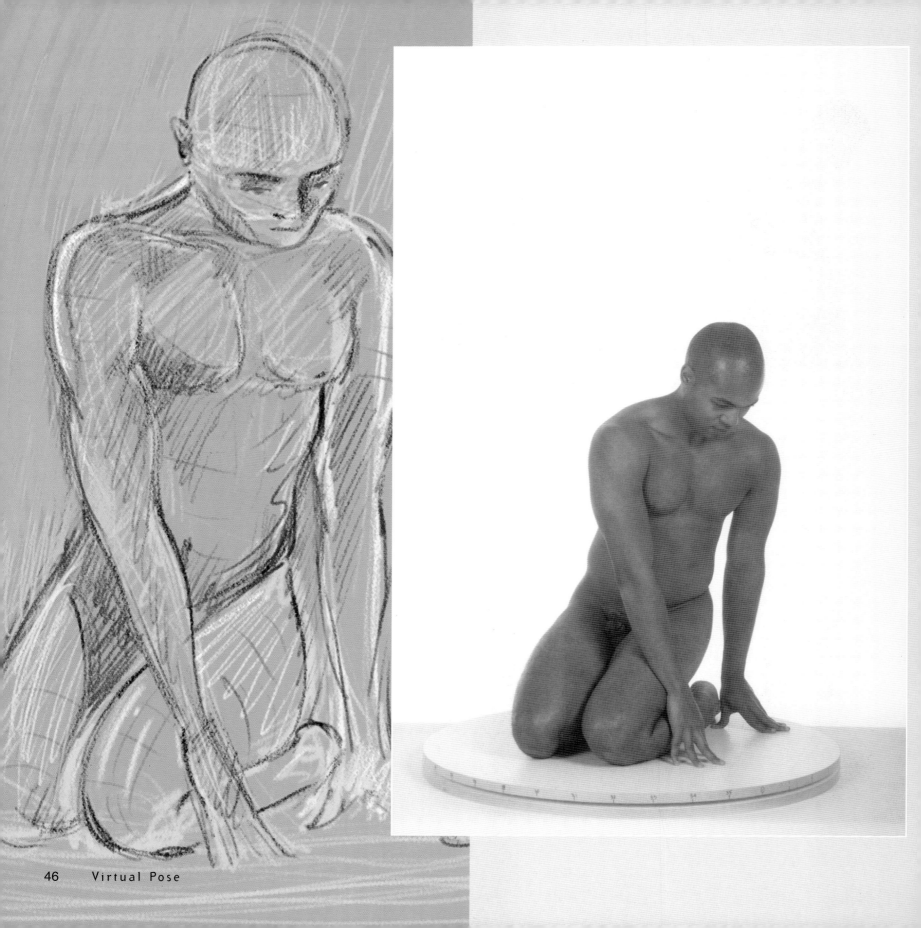

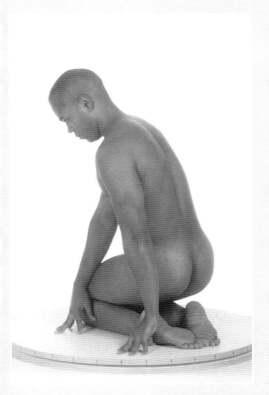
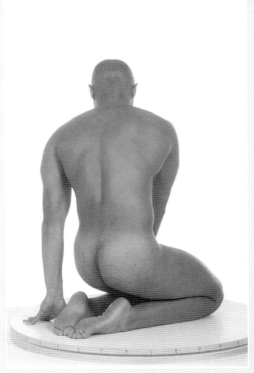
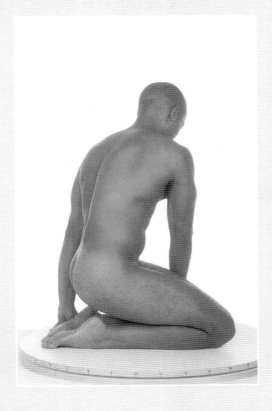
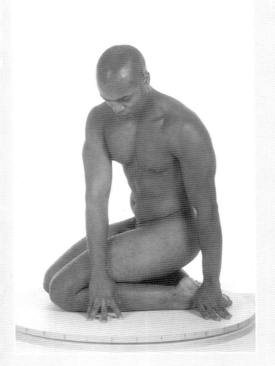
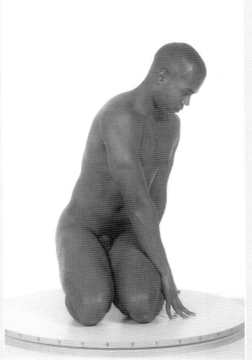
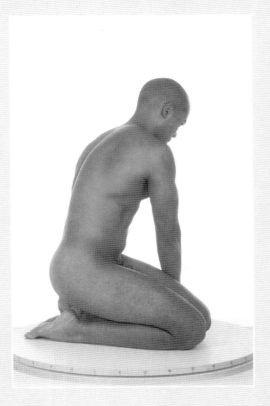

Male Pose 47

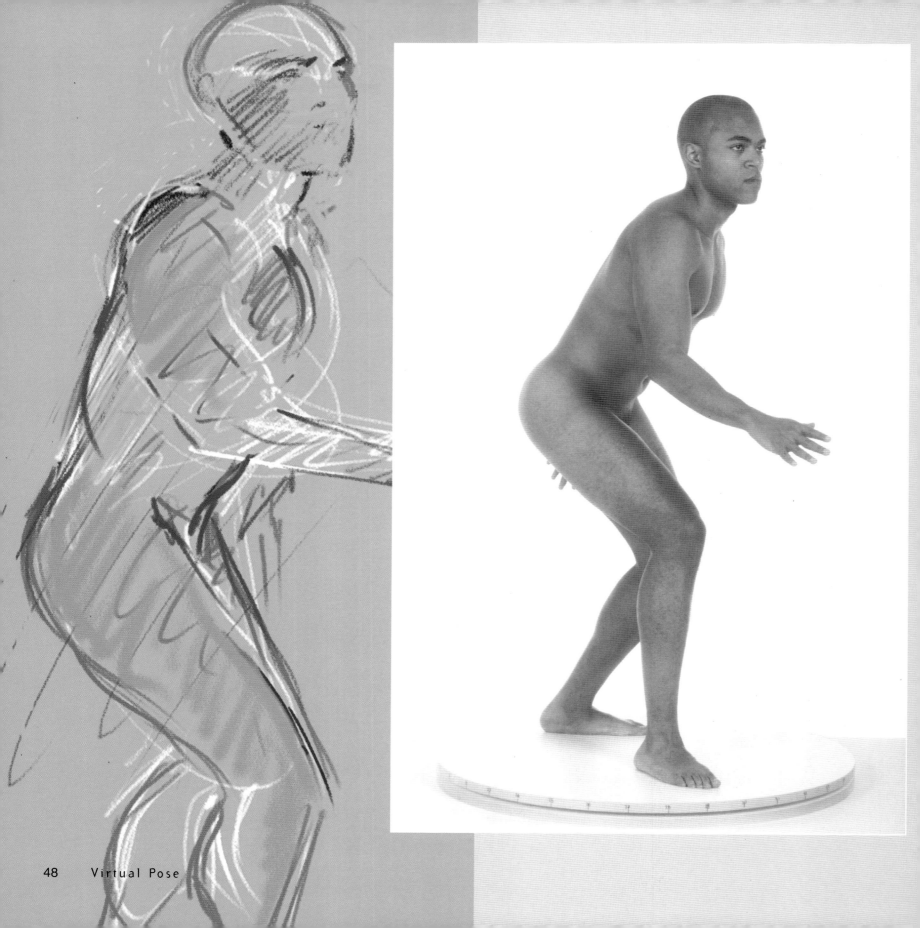

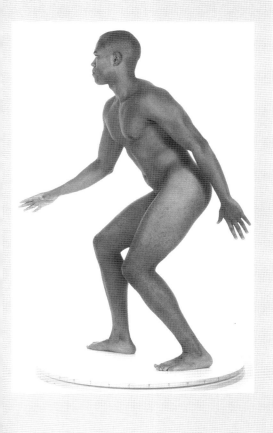
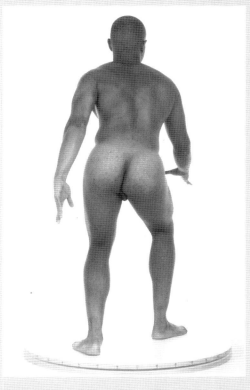
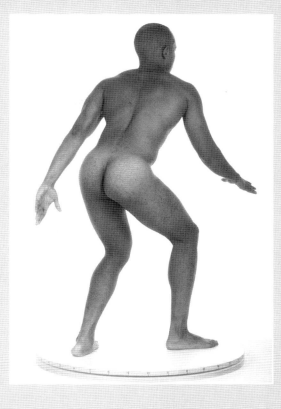
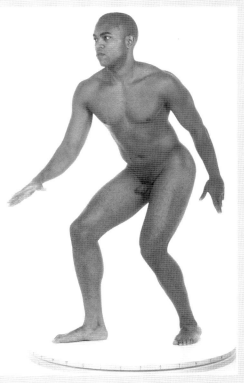
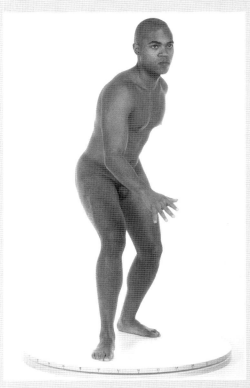
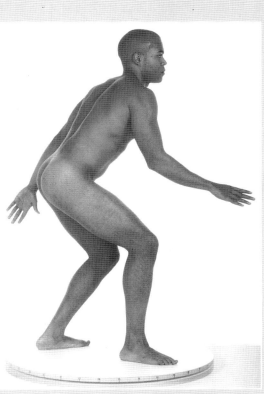

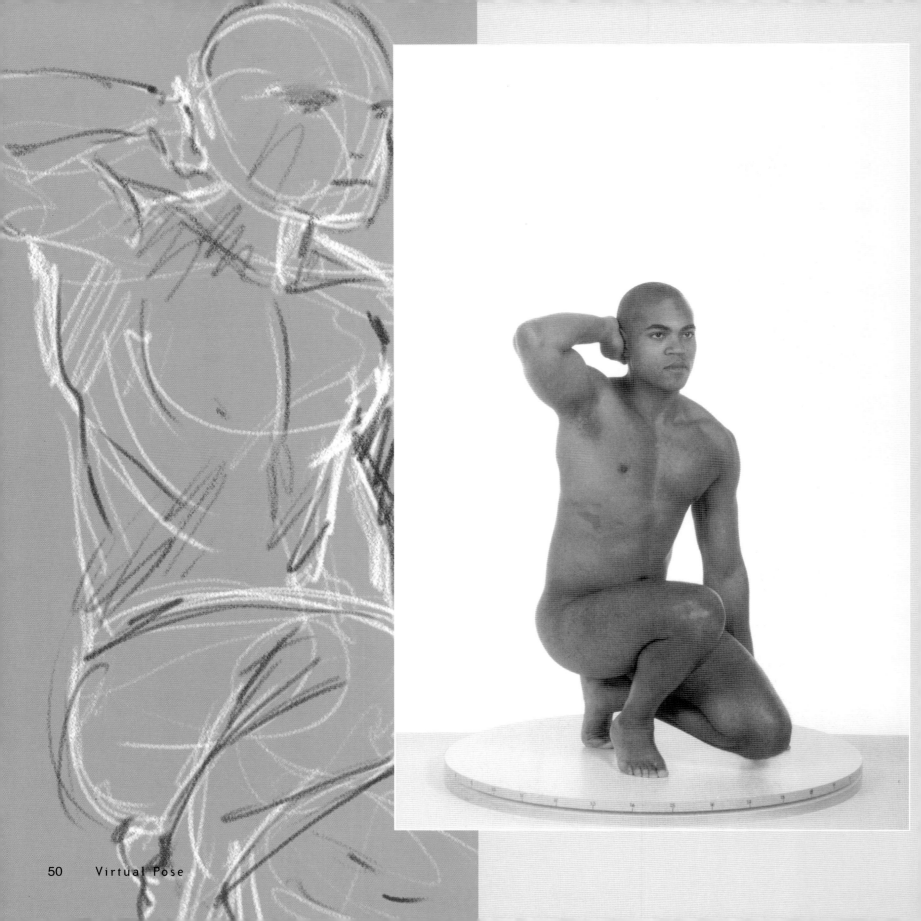

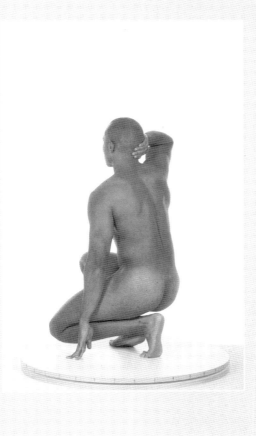
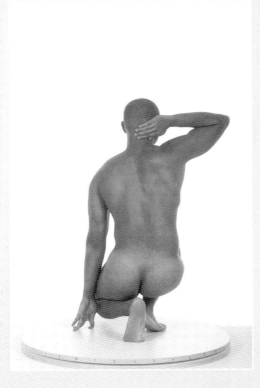
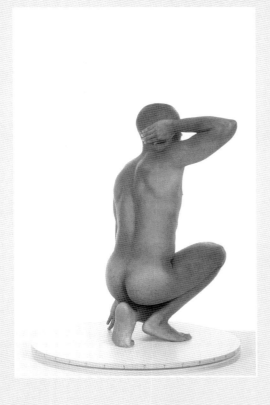
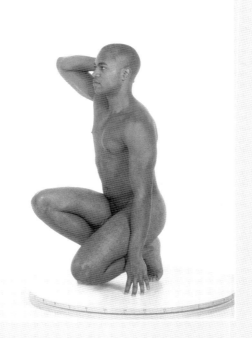
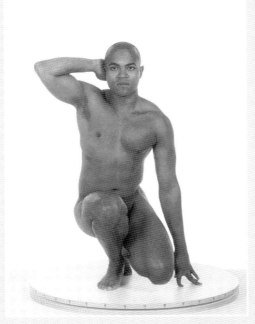
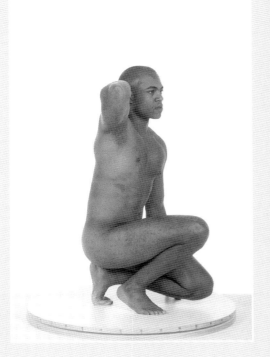

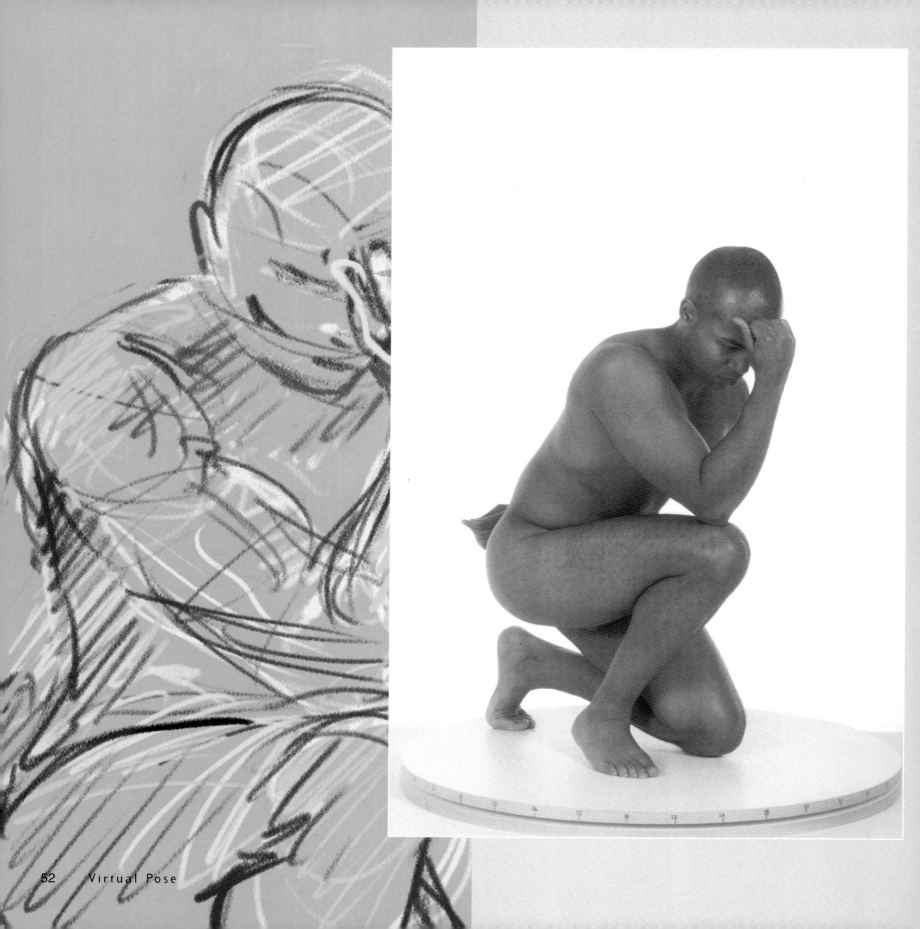

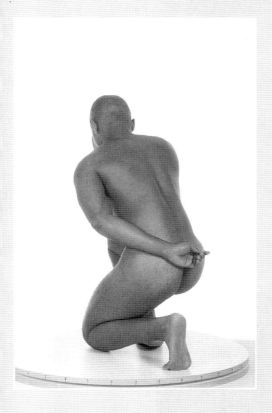
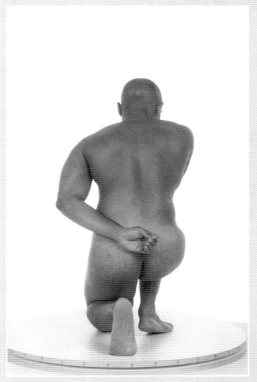
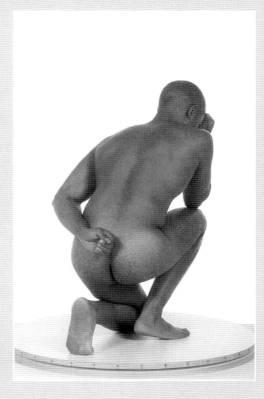
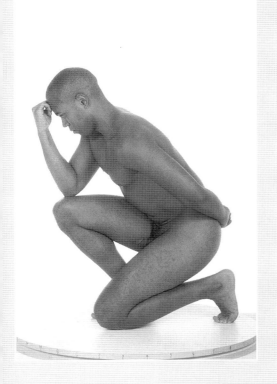
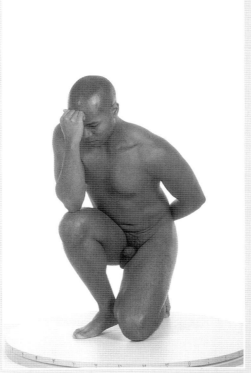
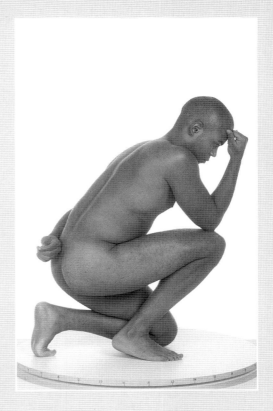

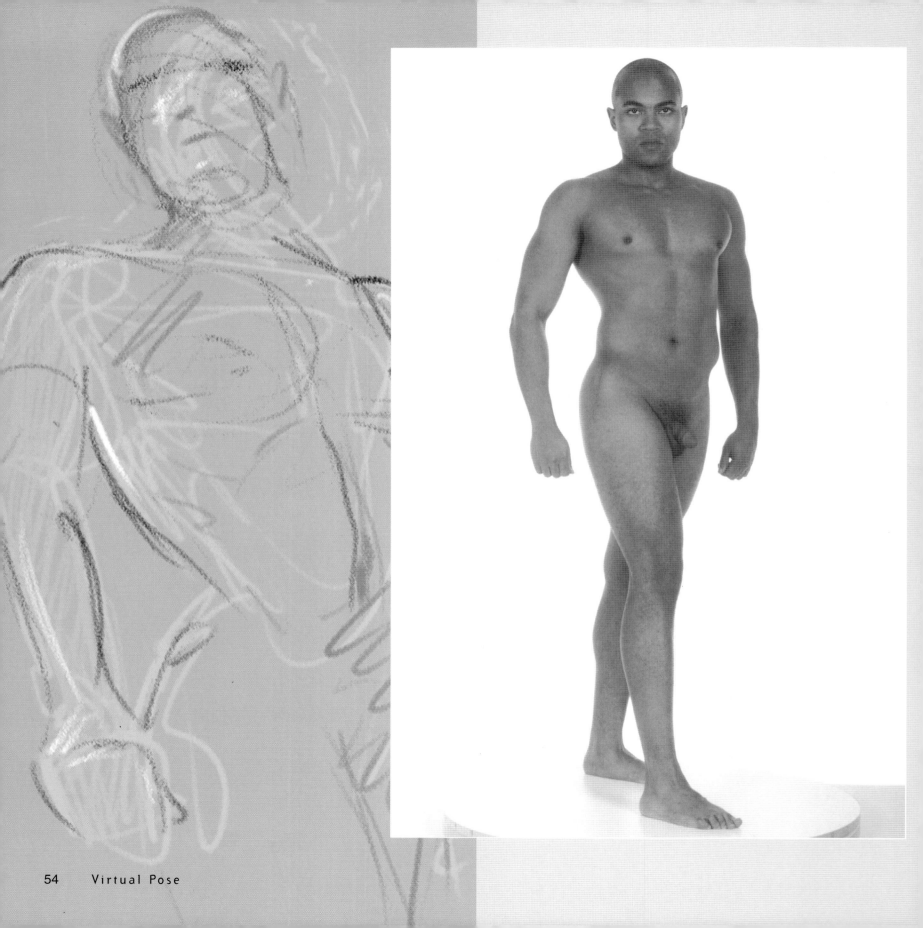

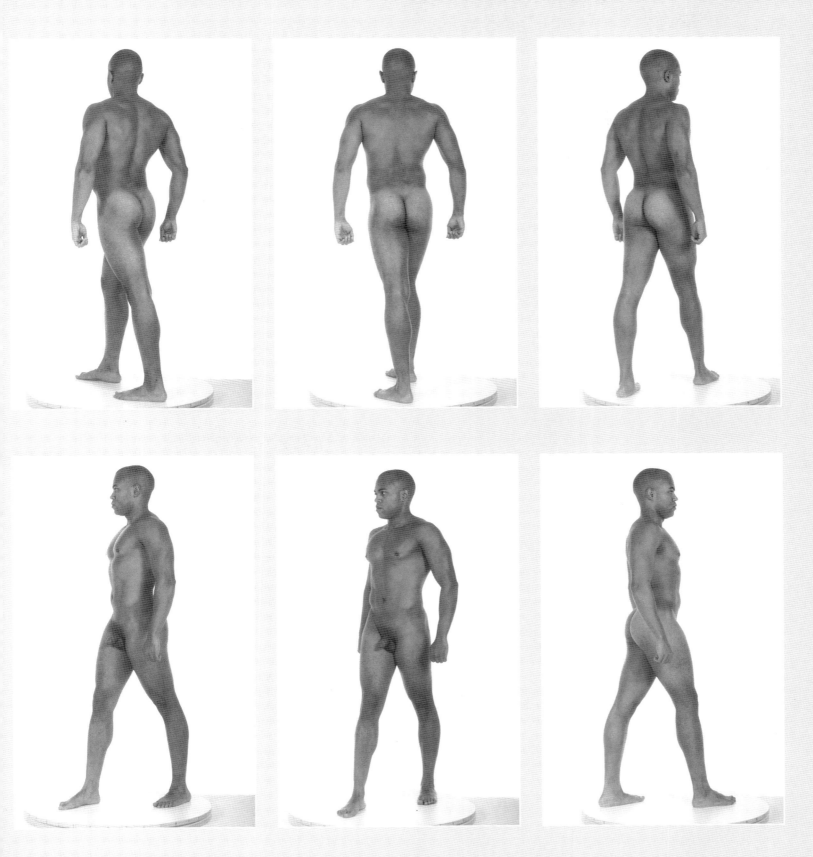

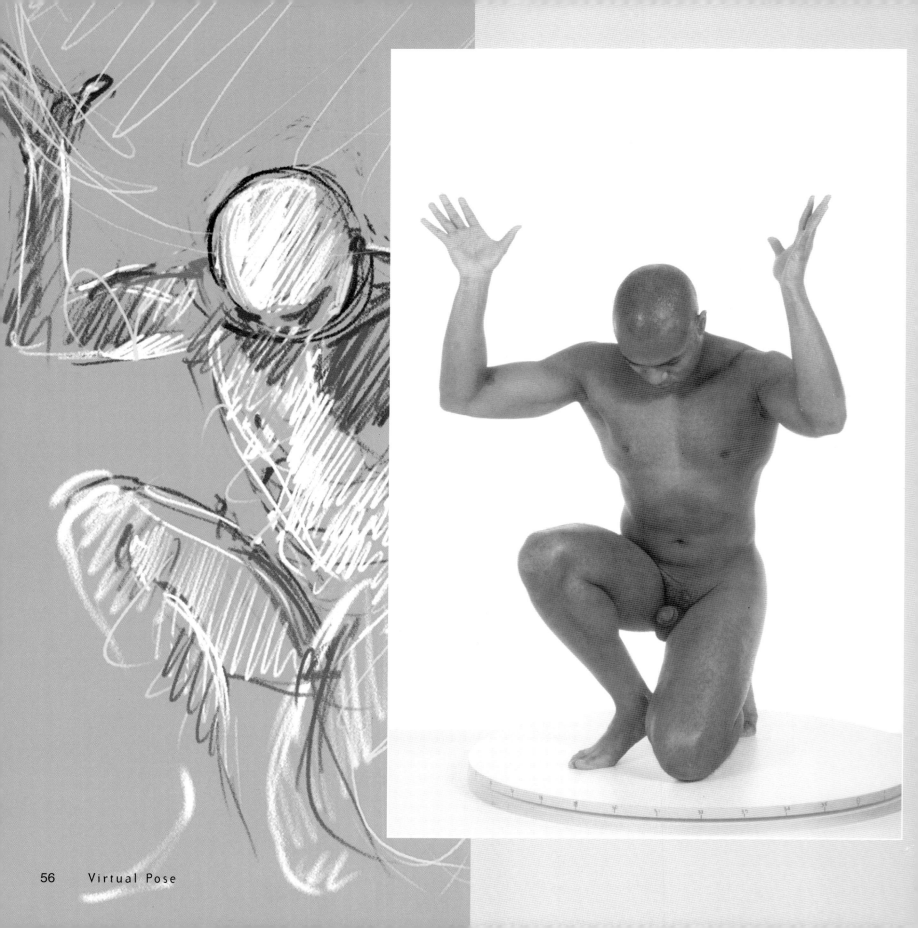

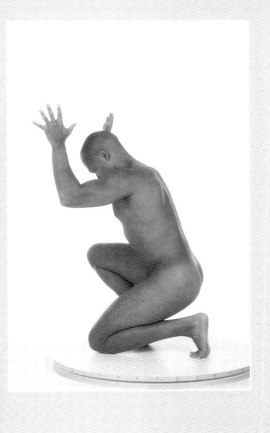
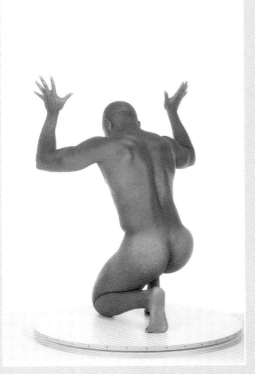
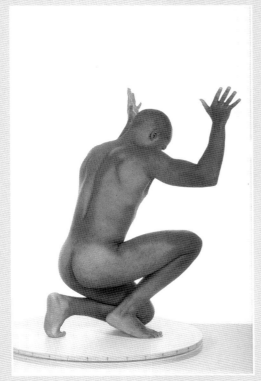
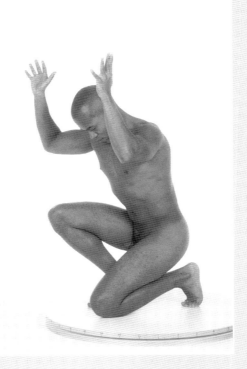
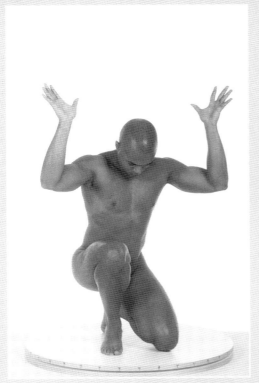
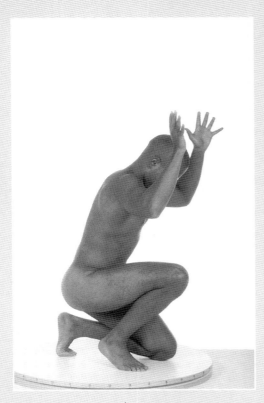

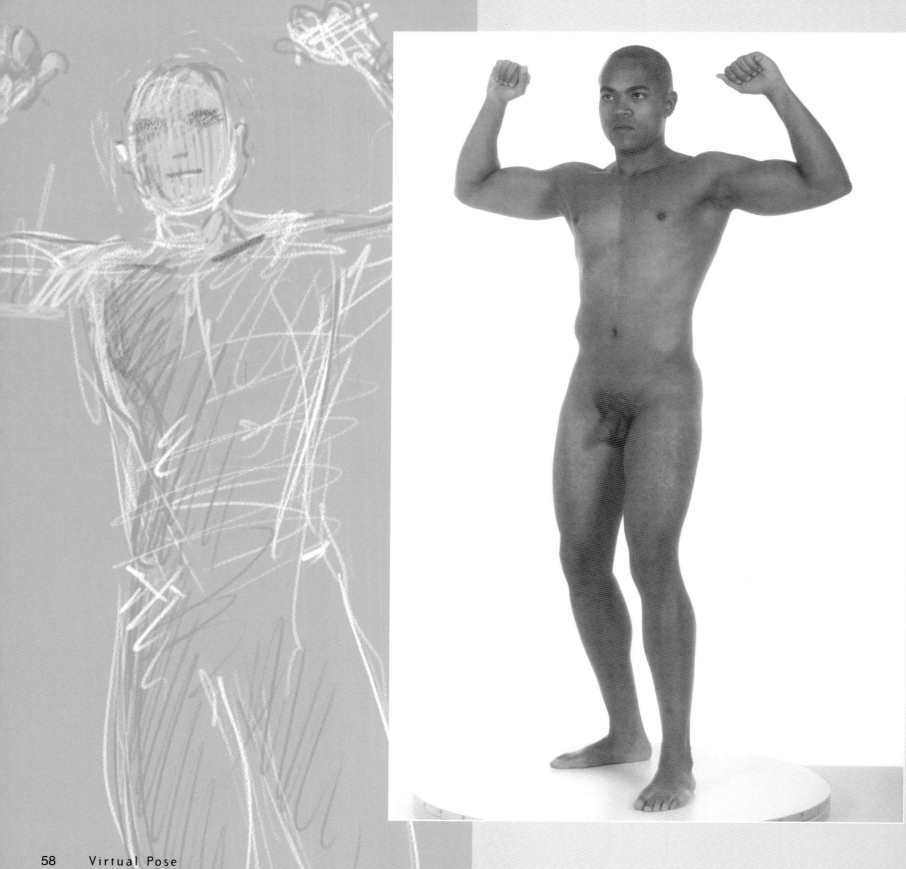

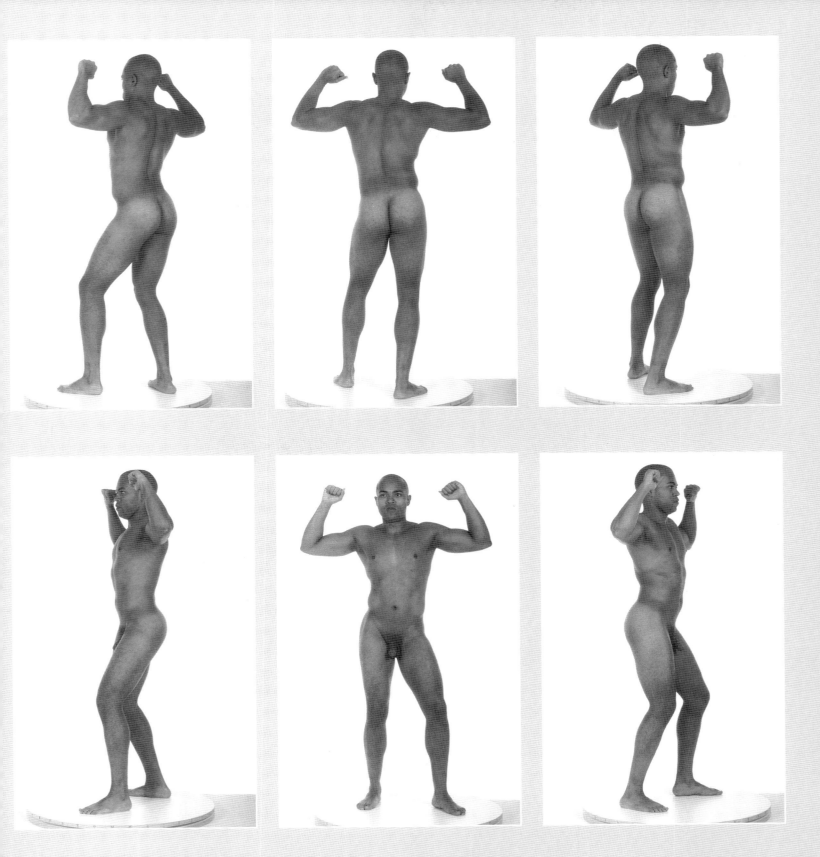

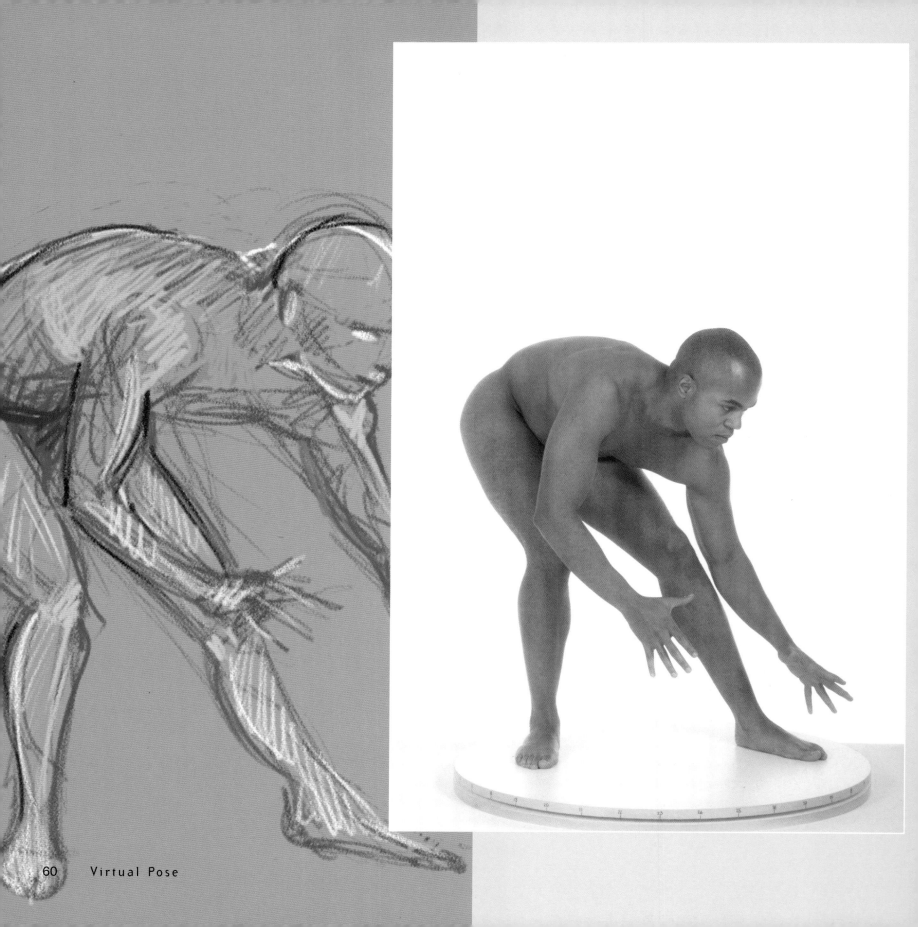

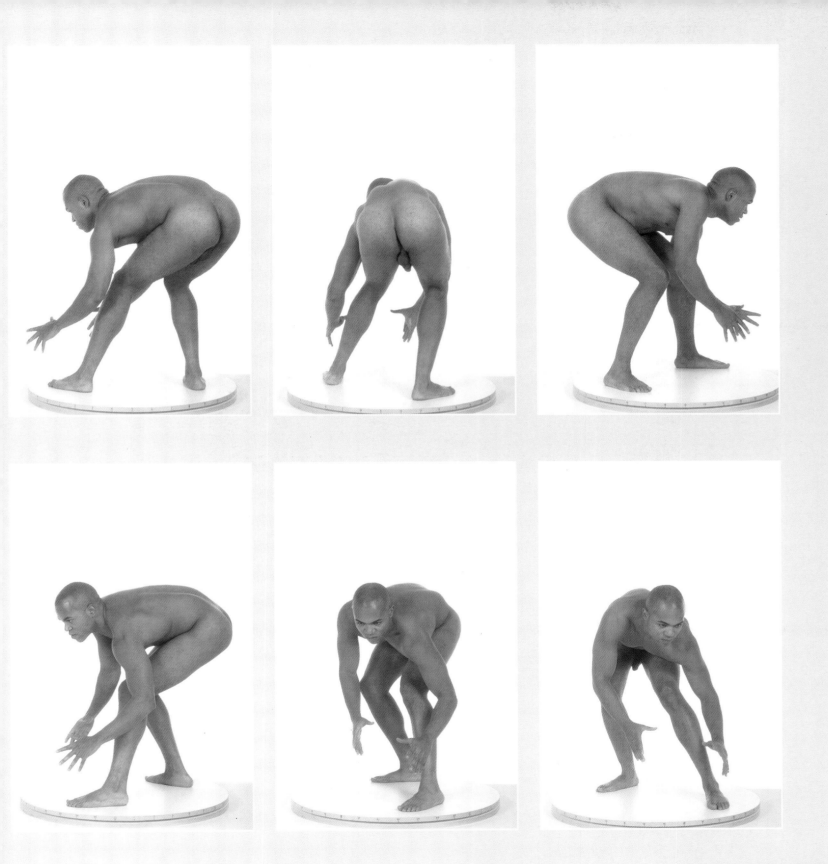

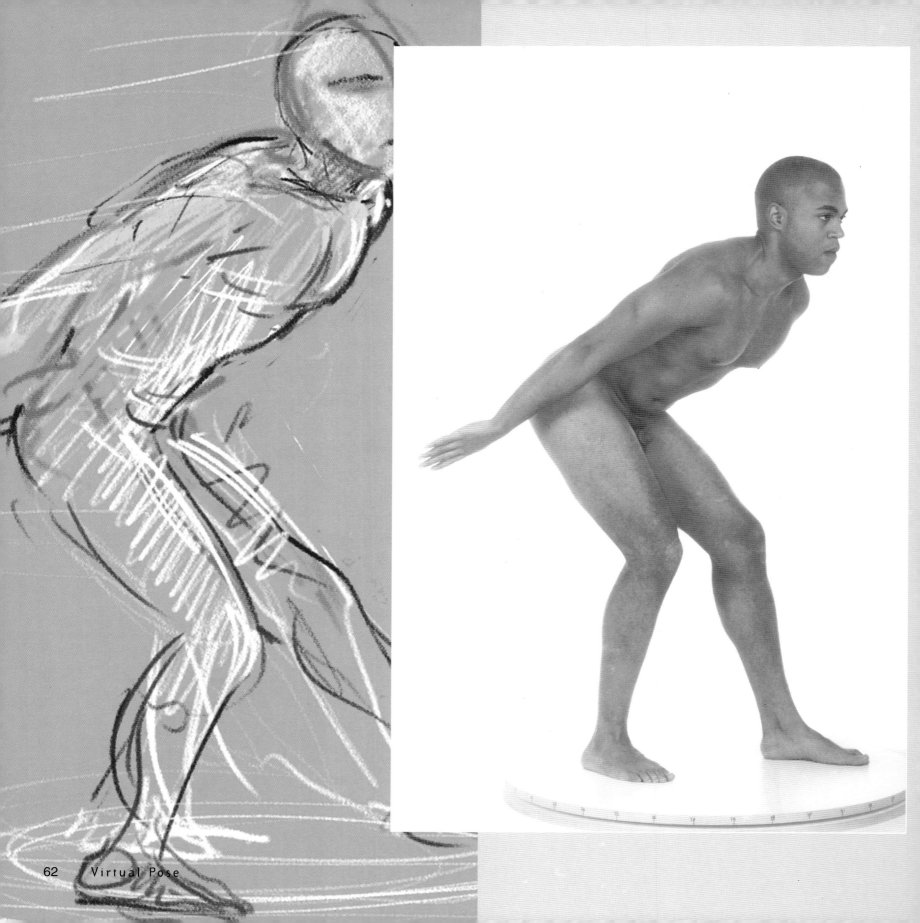

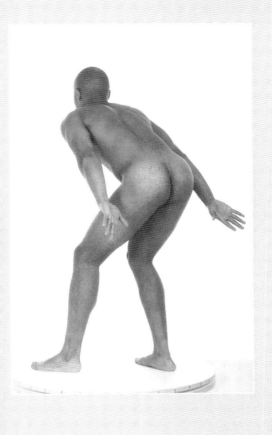
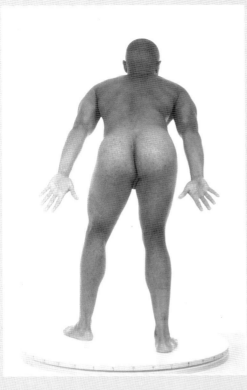
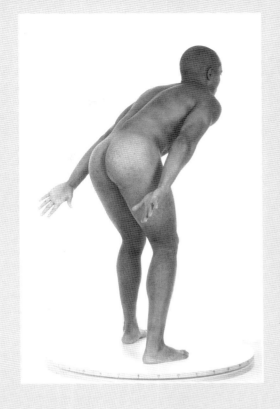
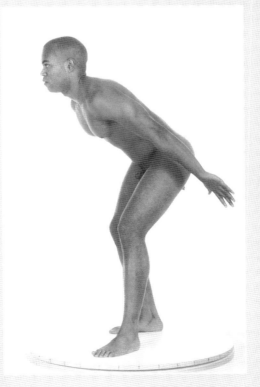
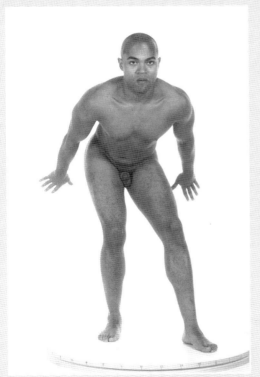
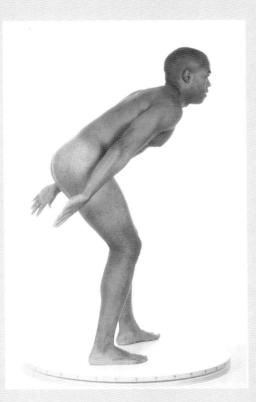

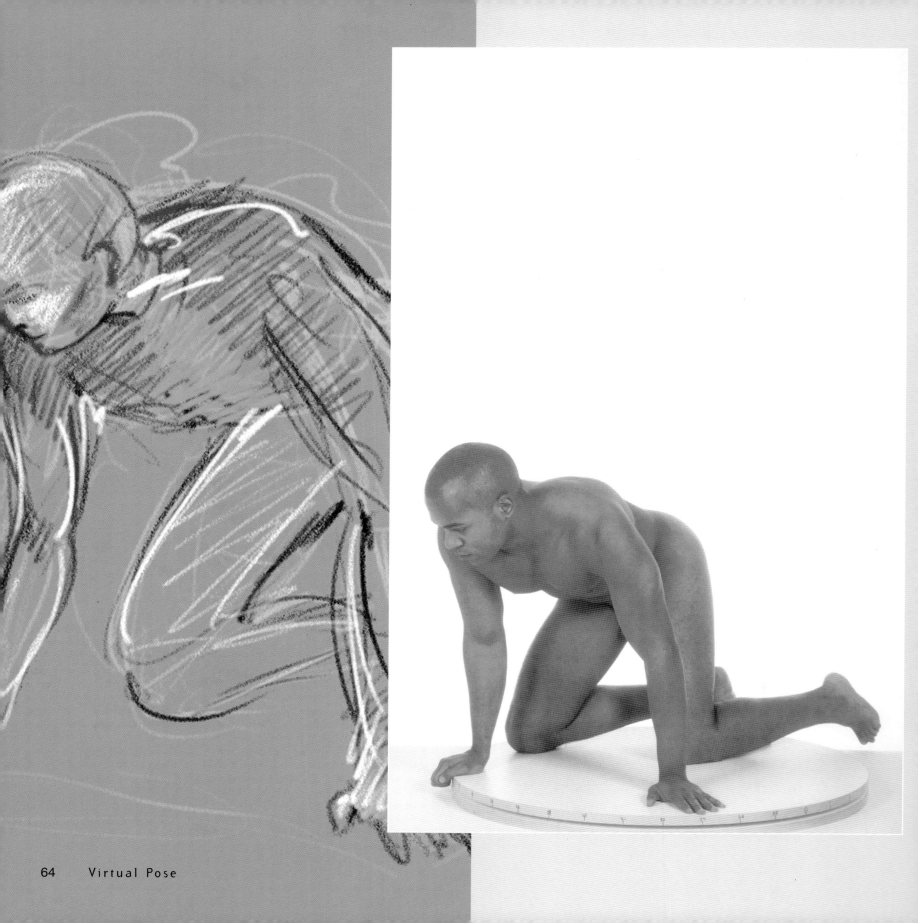

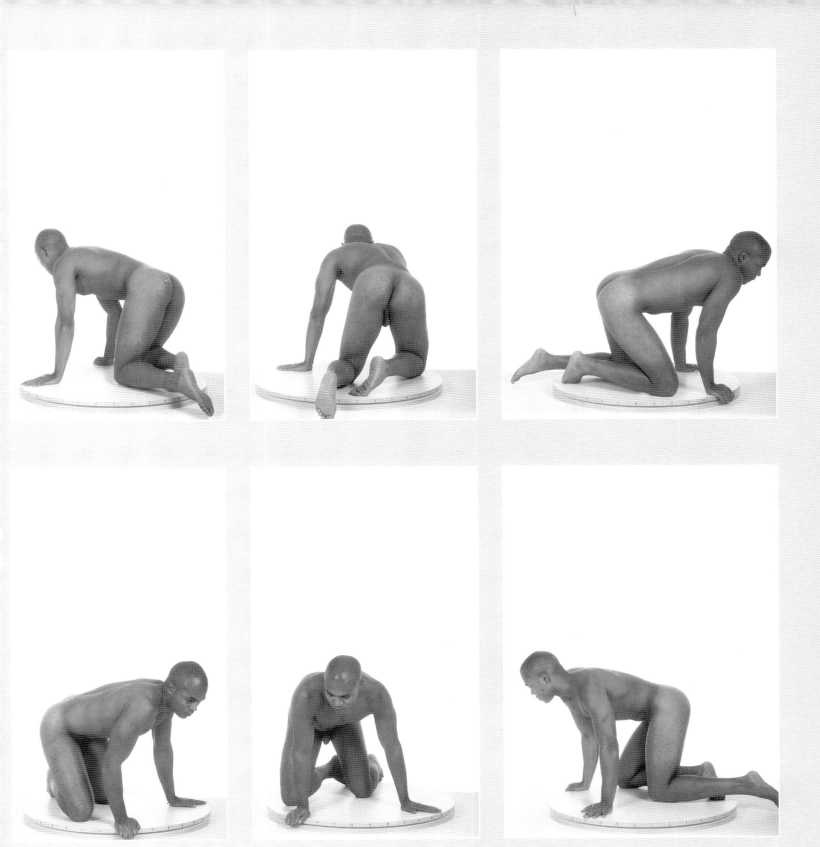

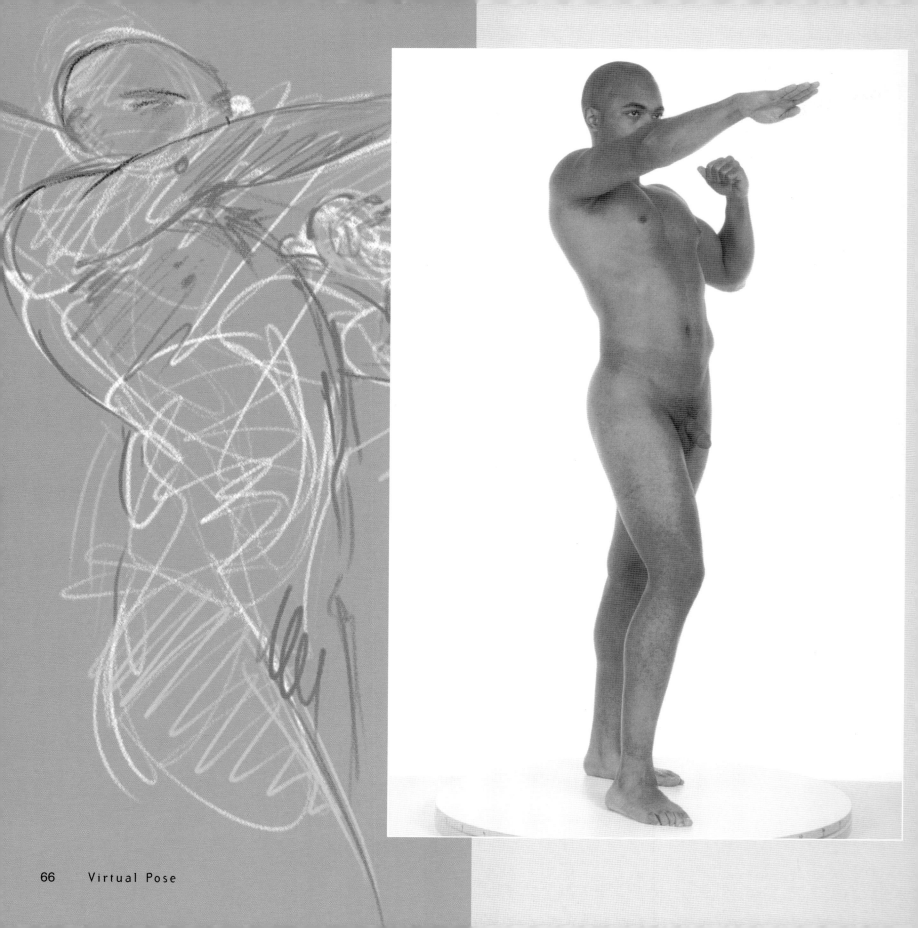

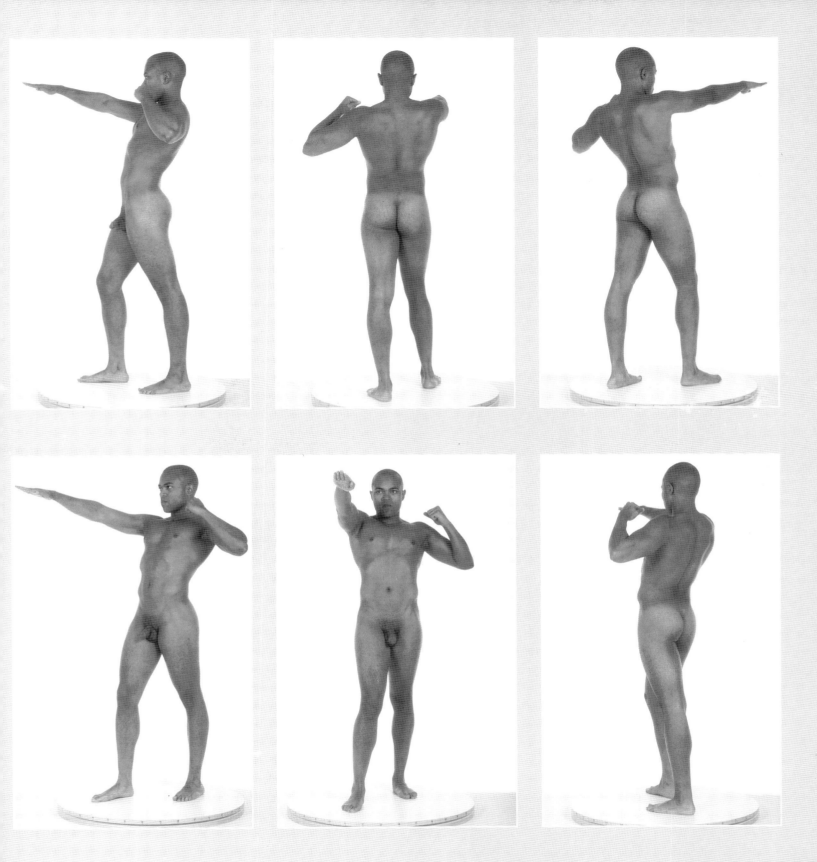

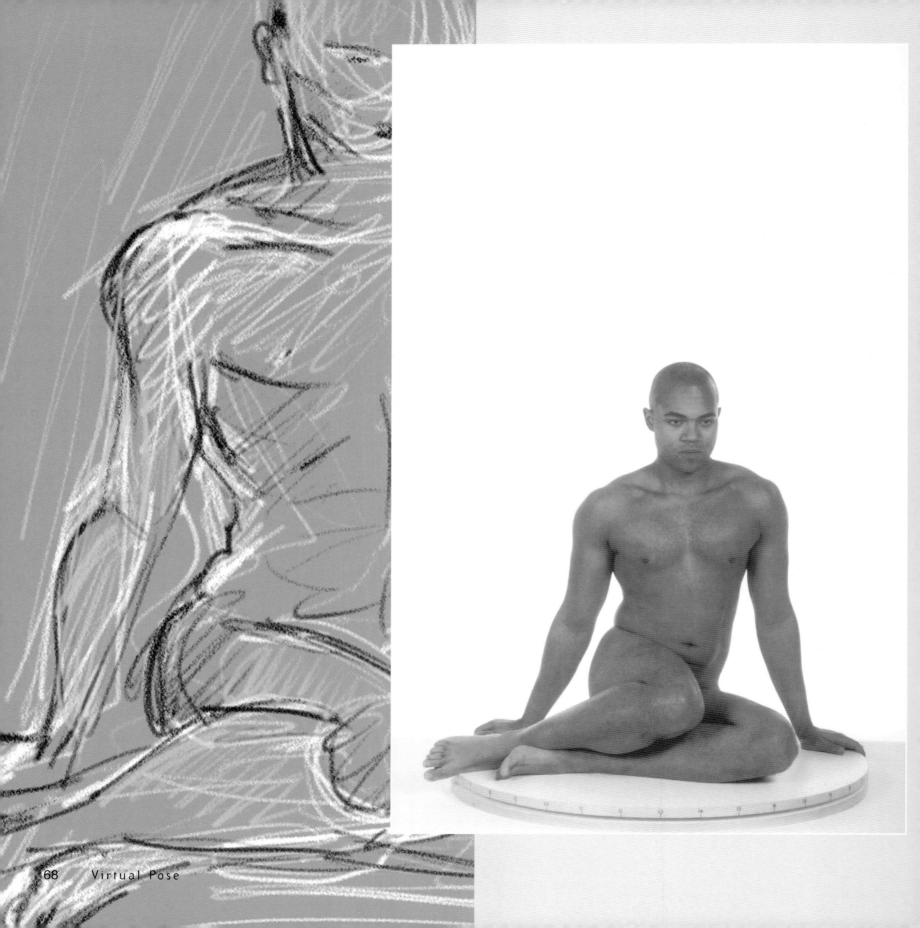

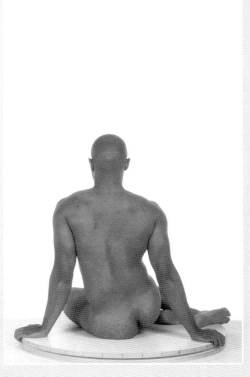
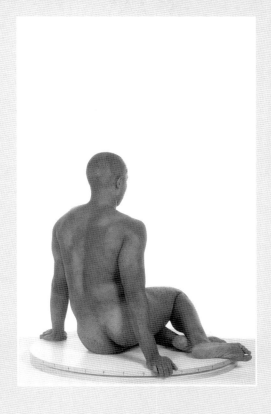
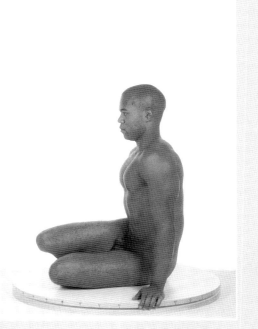
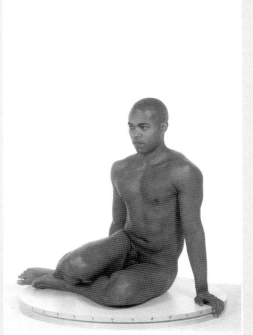

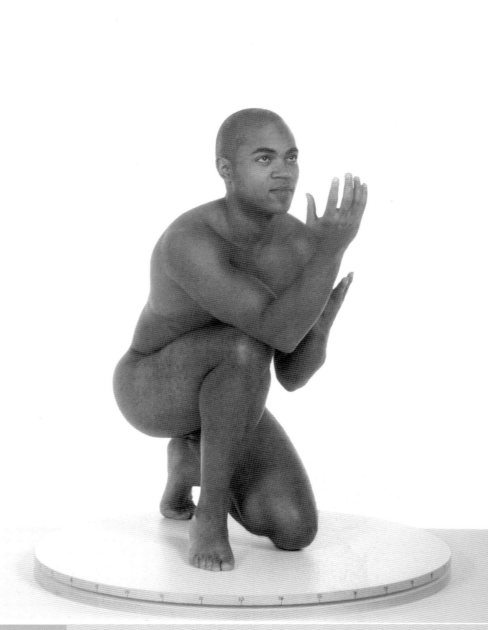

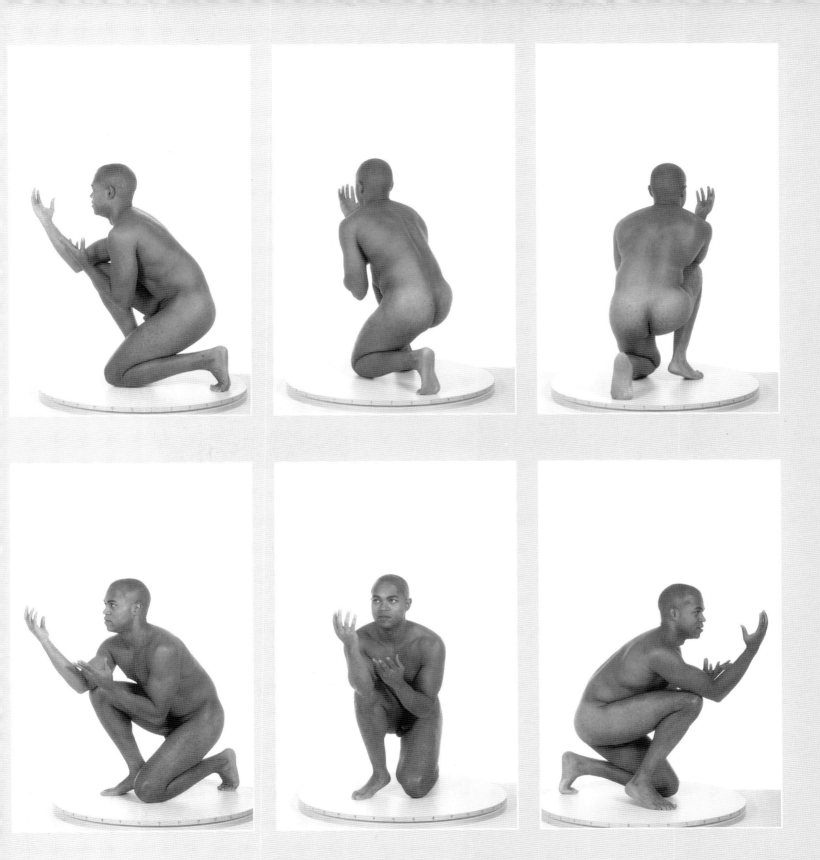

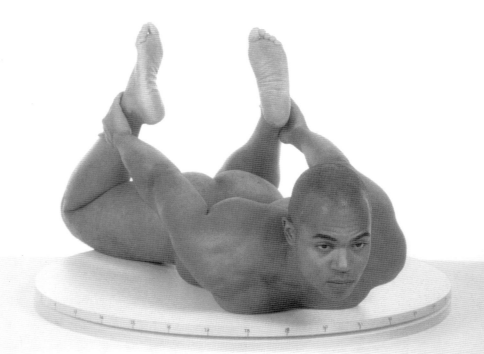

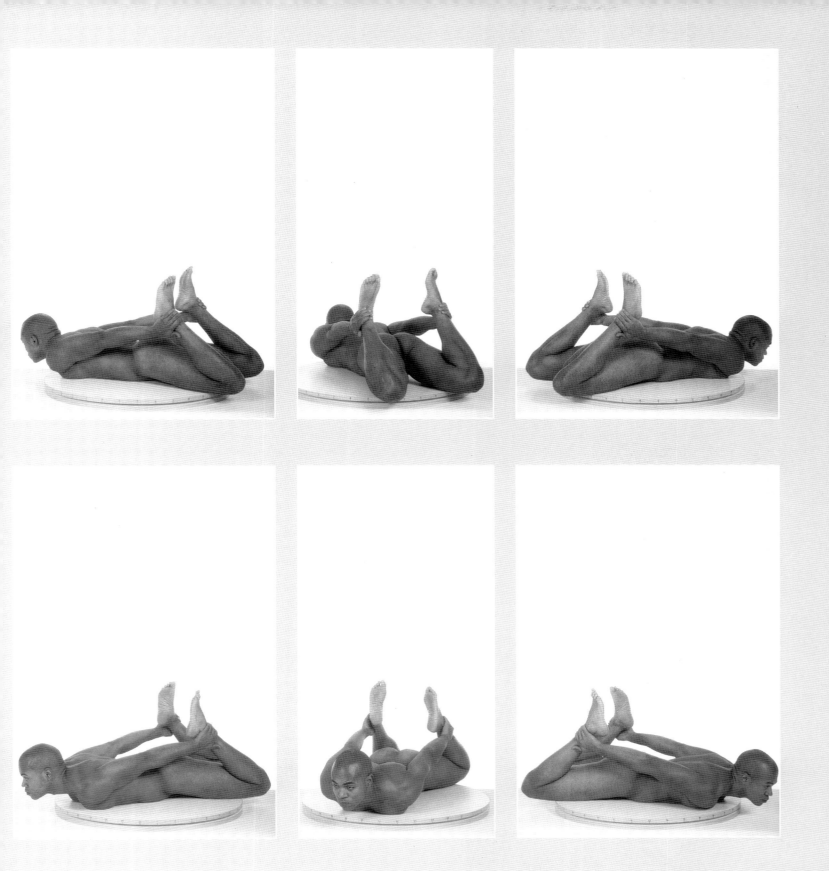

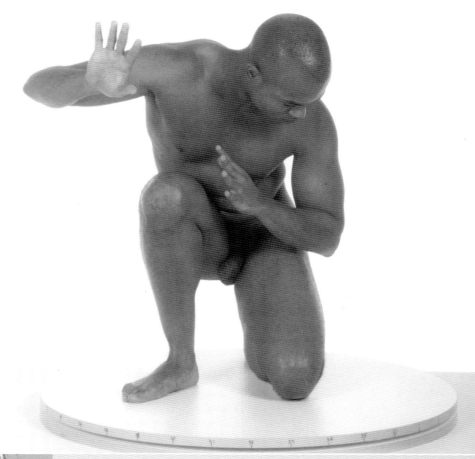

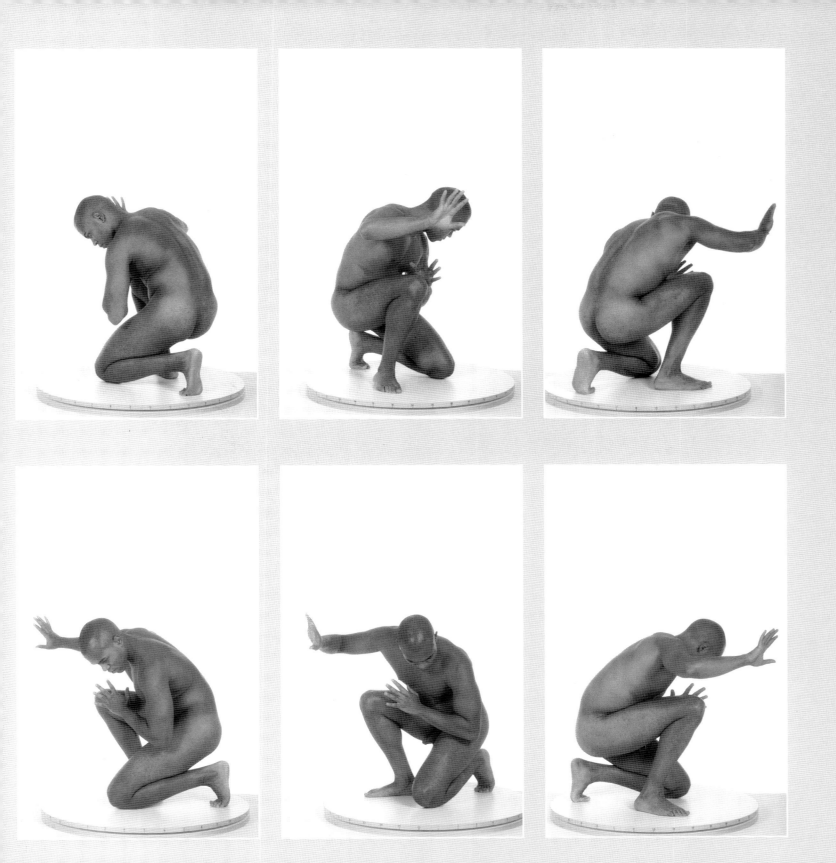

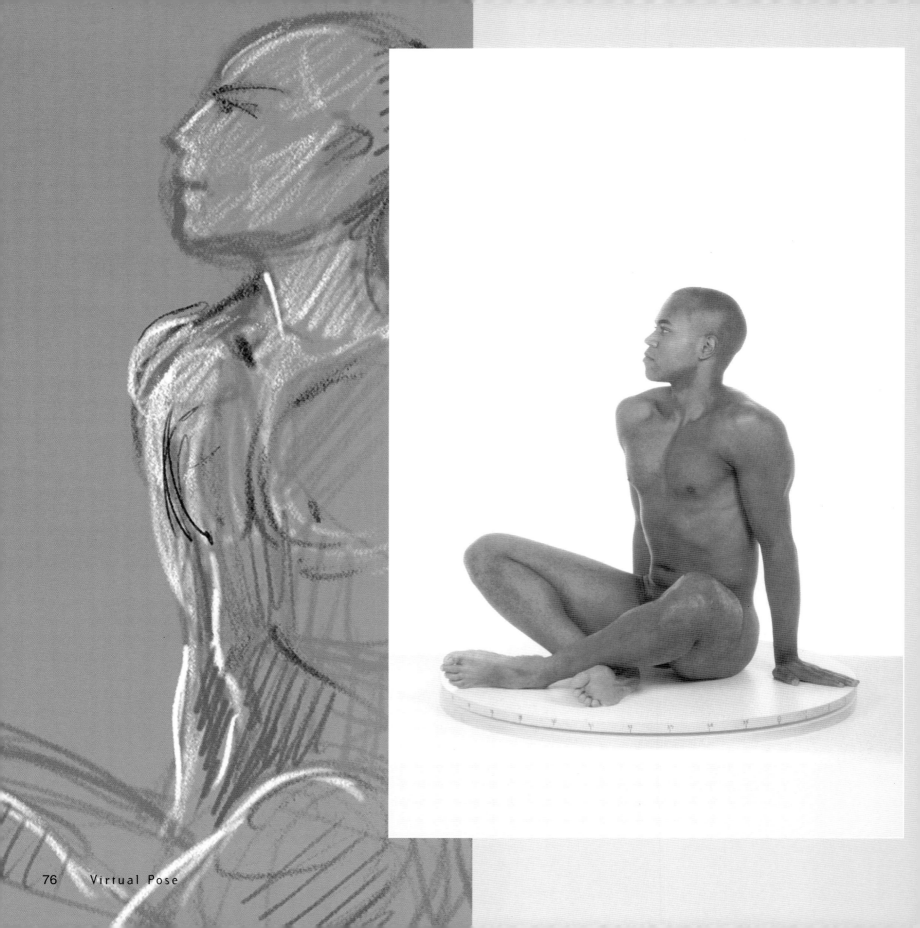

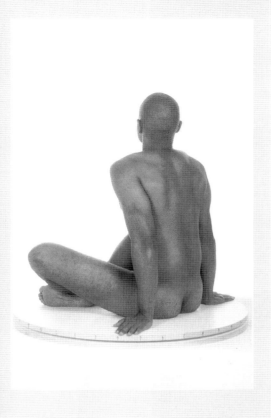
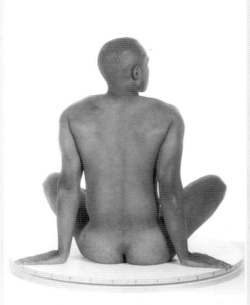
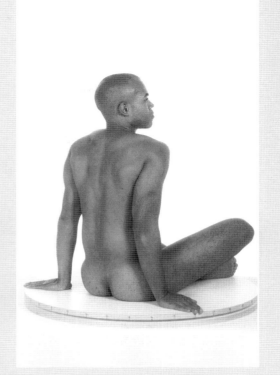
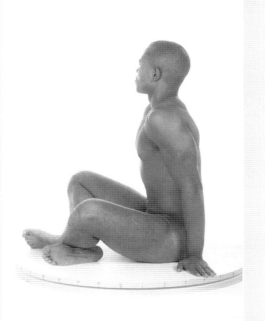
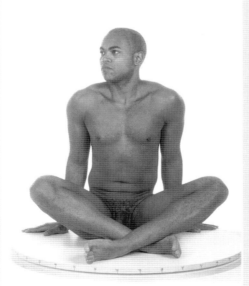
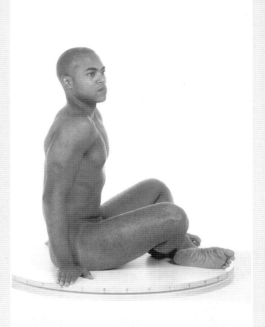

HOW TO USE THIS CD

How to Launch CD:

For Mac: Double-click the VIRTUAL POSE file. Follow the Instructions that appear on your screen.

For PC: From Windows 95/98/NT4.0 Start button, select Run. Type d:\VirtualPose.exe and press Enter (where "d" is your CD-ROM drive letter). Follow the instructions that appear on your screen.

Once the CD launches and the opening credits are done playing, you will be taken to the "nerve center" of VIRTUAL POSE. There, the interface consists of 2 parts. On the right side, you have a selection keypad. On the left side, the stage where the poses will be displayed. You will notice that at this point, the stage is still black, as no pose has been chosen yet.

You will also note that in the selection keypad (right side) both MODELS and RUZENA buttons are depressed and the thumbnails of the female poses are displayed. If you wish to start by drawing the male model, simply press the JASON button. In either case, simply select the pose you would like to draw from, and press on it. The corresponding pose will appear in the stage on the left.

To rotate the model, simply position the cursor in the middle of the screen, click the mouse and drag to the left or to the right. (If using a tablet and digitizing pen, press the nib on the surface of the tablet and drag to the left or to the right.)

You also have the option to zoom in and out, as well as reposition the pose after zooming and rotating in zoom mode.

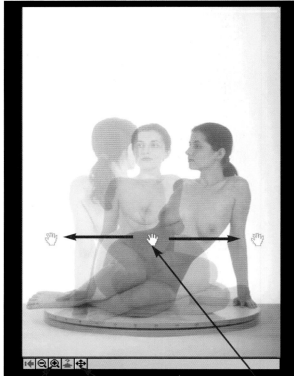
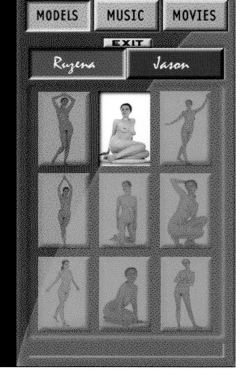

Magnification Tools
To enlarge the size of the pose, click on the magnifying glass icon with the " + " sign.

To reduce the size of the pose, click on the magnifying glass icon with the " – " sign.

Drag Tool
To move the pose within the window, once magnified, press once on the Drag tool icon. The cursor will turn into the Drag tool. Position the Drag tool over the pose, click and drag. Release. To rotate pose again, press on the drag tool icon again. Cursor turns to hand once repositioned over pose. Click and Drag to the left or right to rotate.

Cursor Tool
Cursor turns to hand once positioned over pose. Click and Drag to the left or right to rotate.

(If using a tablet and digitizing pen, press the nib on the surface of the tablet and drag left or right).

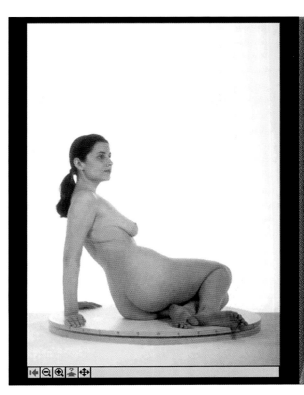

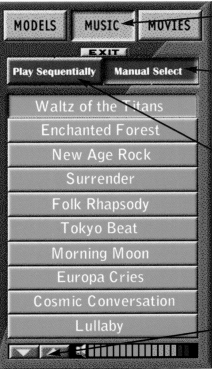

Once a pose is selected, click on MUSIC and, choose one of the two listening modes at your disposal.

Choose MANUAL SELECT to play the music randomly. Simply click on the theme and it will play. After the piece of music has finished playing, you may choose another selection. If you wish to play the whole collection in sequence . . .

Choose PLAY SEQUENTIALLY. While the music is playing, you may rotate and zoom the pose. To choose a new pose, you will need to click on MODELS again and repeat the process.

When in MUSIC and MOVIES mode, two volume control buttons will appear to allow you to set the volume to a comfortable listening level.

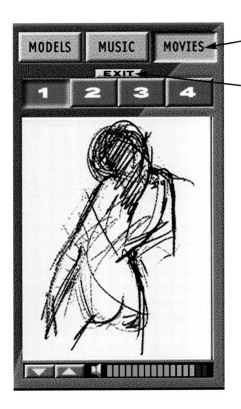

To preview the tutorial MOVIES, press the MOVIES button. A video screen will appear in the selection key pad.

To end the session, press on the EXIT button.

Minimum System Requirements:

MAC: Power Macintosh, 16 Mbytes RAM, 256 color, 4X CD-ROM Drive, System 7.6.1 or higher

PC: Pentium 120MHz processor, 16 Mbytes RAM, SVGA 640x480, 256 colors, 4X CD-ROM Drive (4X recommended), Sound Card, Windows 95/NT 4.0

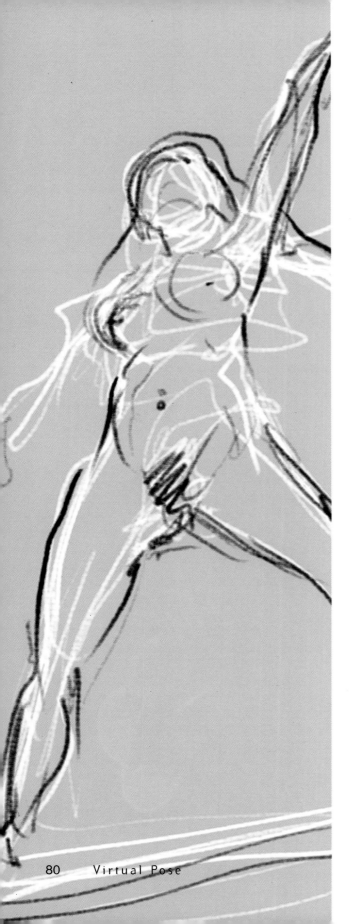

ACKNOWLEDGMENTS

I would like to thank the following people and organizations for lending their time, support and resources to create this project:

Arthur Furst who believed in VIRTUAL POSE, and pulled every string he had to find a publisher that would adopt it. · **Design Books International** for listening to Arthur. · **Donald** and **Janet Traynor** for their amazing marketing efforts. · **Stephen Bridges** for his superb leadership and quality control. · **Ruzena Jelinkova** and **Jason Benson,** for their fantastic work, positive attitude and stamina, despite the many hours of shooting. · **Missy Loewe** and **Models East** for putting us in touch with the best talent. · **John Hansen** of **Velocity Group, LLC,** my agent and close friend, for helping us set up the infrastructure to support this project. · **Mounir Murad** and **PSB Imaging** of Arlington VA, for putting their state-of-the-art Kodak Photo-CD and digital color proofing facility at our disposal. · **David Michael Johnson,** AIA, my former flying buddy, and best friend. He once again saved the day by personally designing and building the rotating platform with the help of **David Robar,** whose company **World Wide Crating Corporation** shipped it to me in one piece! · Many thanks to **Dr. Jon D. Holstine** for knocking on my door on that fateful July 4th night, and inviting us to have dinner with his family and friends, which led to my meeting maestro **Matus Betko,** and the near-instant formation of EmZ™, whose music you hear on the CD. · My partner, producer, and collaborator without whom none of this would have happened, **Gregory Scott Wills.** His mentorship, mastery of the authoring environment and down-right amazing ability to make it look so easy, inspired me to invent content that I hope is worthy of the vessel. · **Theresa (Terri) Parnoff** for her valuable assistance. · **Welton Doby,** for his masterful photography, and whose collection of diecast cars and action figures were a constant reminder of the motivation behind any project — fun. · **Corinne Whitaker,** for keeping me on track. · **Dewey Reid** and **Debi Lee Mandel** for their stamp of approval. · Last but not least, to my wife, thank you for your support, patience and love.